IMAGES
of America

FRUITA

ORIGINAL FRUITA PLAT. After Addison J. McCune surveyed Fruita, William Pabor signed the plat June 1, 1884. Aldrich and Henry Streets, named after town company officers, were soon renamed Aspen Avenue and Mesa Street, respectively. While unnamed in the plat, the street around the park has always been known as Park Square. The park was square at first, but by 1910, photographs show it as circular. (Courtesy of the Mesa County Clerk and Recorder and Mesa County Surveyor.)

ON THE COVER: Blanche Fisher and Don Weimer lead a parade of mounted cowboys westward down East Aspen Avenue as part of the celebration leading up to the Cowpunchers' Reunion of 1921. (Courtesy of the Lower Valley Heritage Chapter.)

IMAGES
of America

FRUITA

Denise and Steve Hight

ARCADIA
PUBLISHING

Published by Arcadia Publishing
Charleston, South Carolina

Printed in the United States of America

Library of Congress Control Number: 2010932247

For all general information, please contact Arcadia Publishing:
Telephone 843-853-2070
Fax 843-853-0044
E-mail sales@arcadiapublishing.com
For customer service and orders:
Toll-Free 1-888-313-2665

Visit us on the Internet at www.arcadiapublishing.com

*To our parents, Randy and Joy Capp and Victor and Carol
Hight, who always encouraged our love of reading and history*

CONTENTS

ACKNOWLEDGMENTS

A large number of people have helped us with this project. We would first like to thank Alan Kania for suggesting we write this book, and Jerry Roberts, our editor at Arcadia, for entrusting us with this project.

We have been gratified to receive so much encouragement and support from many individuals and organizations. Although it is impossible to list them all, they include Bennett Boeschenstein; Frank Cavalieri and the Lower Valley Fire District; Dave Fishell; Bobbi June Fisher; the Fruita Historic Preservation Board; the *Fruita Times*; Fruita mayor Ken Henry; Tiffany Hoffman; Priscilla Mangnall; Cullen Purser; Kevin Switzer; Derick Wangaard of Sanborn Postcards; Mary Lou Wilson; Judy Workman; the enthusiastic members of the Fruita business community; and, of course, our families.

This history would not be possible without the contribution of those who spent many years collecting the stories, artifacts, and photographs that make up Fruita's story. Although we never met Earlynne Barcus and Irma Harrison, we owe them a great deal of thanks and gratitude. We also owe thanks to Gene Thomas, former publisher and editor of the *Fruita Times*. The history articles printed during his tenure have been invaluable.

We especially thank Yvonne Peterson, chairperson of the Fruita Historic Preservation Board and head of the Lower Valley Heritage Chapter, for giving us free rein in the Fruita Heritage Room and allowing us to take home and scan photographs from the extensive collection she has amassed over the years. Without her efforts, much of Fruita's story would have been lost. Unless otherwise noted, all images appear courtesy of the Lower Valley Heritage Chapter.

Images of America: *Fruita* is not intended to be a comprehensive history of Fruita. It is, rather, a photographic look at some of the highlights of Fruita's story. It has been our pleasure to compile this book, and we hope it will spur interest in Fruita's history and encourage researchers and students to investigate further. We apologize for any inconsistencies; we have used a large number of sources to compile this history, and we have found that dates, exact locations, and recollections do tend to vary.

INTRODUCTION

The motto of the city of Fruita, Colorado, is "Honor the Past, Envision the Future"; but although Fruita has a fascinating past, that past has not been very accessible to the general public. That, perhaps, is not very surprising, as there is little in print about Fruita's history. Although a large number of books have been published about nearby Grand Junction, the last time a book was published about the history of Fruita was in 1983, to commemorate Fruita's centennial in 1984. The book, *Echoes of a Dream—The Social Heritage of the Lower Grand Valley of Western Colorado*, is a compelling compilation of stories written about and by the early settlers of the Lower Grand Valley, but it has long been out of print.

When we moved to Fruita from Grand Junction in 2001, we quickly became fascinated with the history of the area and particularly with that of its founder, William Edgar Pabor. Pabor, born in 1834, was a well-known poet and musical lyricist whose work was published in the major periodicals of the time, including *Godey's Lady's Book*, *Ballou's Pictorial*, and *Peterson's*. Pabor served as a postmaster and a newspaper editor in his native New York City, but once he became acquainted with the philosophies of Horace Greeley, he followed the advice to "go West, young man" and left New York for Colorado in 1870. Pabor became enthralled with "the valleys, plains, and parks of Colorado" and with the territory's potential for agriculture in particular. He contributed to and edited several journals and newspapers, including the *Colorado Farmer*, and he wrote several books, including *Colorado as an Agricultural State: Its Farms, Fields, and Garden Lands* and *Fruit Culture in Colorado: A Manual of Information*. Pabor also assisted in the establishment of the towns of Greeley, Colorado Springs, and Fort Collins before making his way in 1883 to Western Colorado.

When Pabor arrived in the area that would soon become Fruita, the landscape, before the advent of irrigation, would have been a desolate sight, but Pabor saw something entirely different:

> In the spring of 1884, lying on the bare floor of a log cabin on the site of what is now the town of Fruita, I watched the moonbeams play on the Roan Cliffs and across Pinon Mesa. The silence of centuries seemed resting upon the plain . . . But visions of the possibilities of the future swept before me. I saw homes founded, I saw family circles gathered together. I saw vineyards and orchards, and rose-embowered cottages in which love and happiness and contentment abode . . . I heard the merry voices of children yet to be born. I heard the singing of harvesters bringing in the sheaves of golden grain.

This area, which for millennia had seen little change, was about to be changed forever by the vision of William Pabor. Pabor's plan for Fruita was to use irrigation water from the nearby Colorado River (then called the Grand River) to create an agricultural paradise. For a number of years, it appeared that his vision would become a reality, and fields and orchards, primarily apple orchards, were planted and thrived. But this agrarian vision suffered a severe blow when, beginning in the

1910s, the coddling moth and a series of spring freezes destroyed most of the apples. Although the farmers tried to save their orchards with smudge pots and pesticides, primarily arsenate of lead, it was a losing battle, and by the early 1920s, most of the trees had been pulled up. The majority of the farmers, however, did not abandon their land; instead they continued to cultivate other crops that had already proven successful in Fruita, such as potatoes, sugar beets, and alfalfa.

Around the same time that Fruita was founded, other developers were also establishing towns in the area. Some of these towns, such as Cleveland, were eventually incorporated into Fruita; others appeared on maps briefly and just as quickly disappeared; while others still, such as Loma, Mack, and the Redlands area, with its picturesque backdrop of the scenic Colorado National Monument, survived and thrived. Of course, Fruita's most influential neighbor is the much larger city of Grand Junction, some 15 miles to the east. Residents of Fruita have always commuted to Grand Junction, initially by horse and wagon, then by the Interurban railway line, which ran a passenger service between Fruita and Grand Junction from 1910 until 1928, and since then by automobile. But since its founding, Fruita has always been a separate community with its own distinct identity, with its own schools, churches, and businesses, with its own local events, organizations, governing structure, and its own cast of characters. And fortunately for us in the present day, Fruita also had among its citizens a group of photographers who faithfully recorded the businesses and residences and the community events. In the autumn of 1913, Minnie Hiatt photographed every business and every home in Fruita, and unless credited otherwise, all 1913 home or business photographs in this book are hers. Around the same time, Pearl Roach captured images of fairs and festivals and street scenes. And what they missed was caught by Fred Fraser. It is to them that we owe much of our knowledge of early 20th-century Fruita, and without their work this book would not have been possible.

William Pabor was a restless wanderer, and after he left Fruita for health reasons, he settled in Florida, where he founded another town that he called Pabor Lake. But his love for Fruita never diminished, and after his death in 1911, he was returned to Fruita and laid to rest in Fruita's Elmwood Cemetery. In one of his many works of poetry, *Wedding Bells—A Colorado Idyll*, he describes the place he loved best:

Fair Fruita, in the sunshine lies,
The fairest village beneath the skies;
Broad sweep of fertile land around,
Where prosperous farmer homes abound;
Home of the almond, apple, peach,
And vines, whose purple clusters teach
That bounteous Nature offers here
A generous summer with each year.

Pabor had a vision of a thriving, prosperous community. More than 125 years after its founding, Fruita is indeed thriving. With this history, it is our intention to "Honor the Past" and "Envision the Future" of Fruita and celebrate the legacy of William Pabor and those early pioneers who followed in his stead.

One

A POET'S VISION

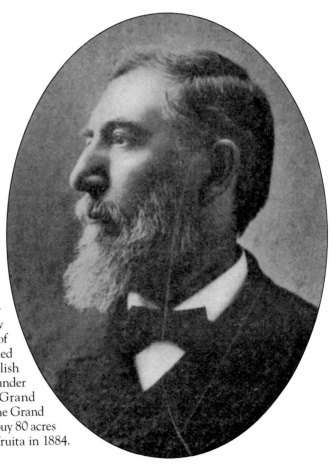

WILLIAM PABOR, FOUNDER OF
FRUITA. William Edgar Pabor
came to Colorado from New
York City in 1870 as secretary of
the Union Colony that established
Greeley. He then helped establish
Colorado Springs and was cofounder
of Fort Collins. Arriving in Grand
Junction in 1883 to reorganize the Grand
River Ditch, he was inspired to buy 80 acres
a few miles west and establish Fruita in 1884.
(Authors' collection.)

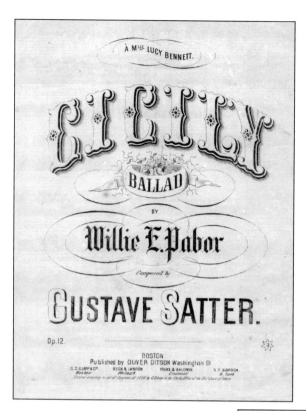

SONG LYRICS BY WILLIAM PABOR. Before Pabor came to Colorado, he worked at a pharmacy, as a newspaper editor, and as a postmaster. Although he received no formal education beyond the age of 12, he was a nationally known poet and lyricist. His poems appeared in leading publications, including *Godey's Lady's Book*, *Peterson's*, and *Ballou's*. The music and lyrics for "Cicily" were published in 1856. (Authors' collection.)

COMPILATION OF WILLIAM PABOR'S POETRY. Pabor traveled all over the United States and was active in many organizations. He served, for example, as secretary and poet laureate of the National Editorial Association. Each year, Pabor would address the NEA convention with one of his poems. Twelve of these poems, read before the association between 1886 and 1901, were compiled into a book titled *Twelve Inspirations*. (Authors' collection.)

TWELVE
INSPIRATIONS

ANNUAL POEMS

READ BEFORE THE

NATIONAL EDITORIAL ASSOCIATION
1886 - 1901

BY WILLIAM E. PABOR

WITH AN INTRODUCTION BY
B. B. HERBERT, *of the National Printer-Journalist*

AND

AN APPENDIX CONTAINING COLORADO, NEW
YORK AND FLORIDA SECTIONS.

W. E. AND F. G. PABOR, PUBLISHERS
DENVER, COLORADO
1901

POETRY INSPIRED BY COLORADO.
William Pabor continued writing poetry throughout his life. Among his many published works was a book-length lyric inspired by his love of nature and scenery, *Wedding Bells—A Colorado Idyll*, that was published by his son Frank Greason Pabor, an editor in Denver, in 1900. A number of Pabor's poems were published in *Rhymes of the Rockies*, an anthology of poetry "descriptive of scenes . . . as viewed from trains of the Denver and Rio Grande Railroad," published in 1895. Pabor was probably the anonymous author and editor of that 64-page booklet. As well as being published under his own name in it, Pabor used the pseudonym Edgar P. Vangassen, composed of elements of his own name plus a phonetic respelling of his mother's maiden name, Wingassen. (Both, authors' collection.)

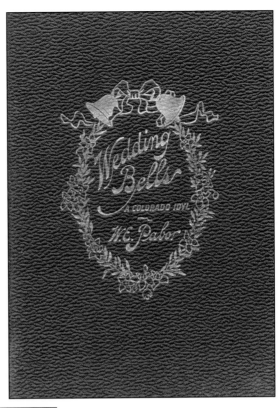

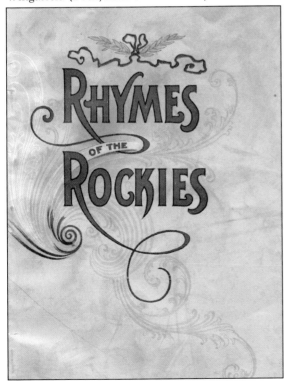

COLORADO

AS AN

AGRICULTURAL STATE.

ITS

FARMS, FIELDS, AND GARDEN LANDS.

BY

WILLIAM E. PABOR.

ASSOCIATE EDITOR OF THE "COLORADO FARMER," AUTHOR OF "FRUIT CULTURE IN COLORADO," ETC.

ILLUSTRATED.

NEW YORK:
ORANGE JUDD COMPANY,
751 BROADWAY.
1883.

WILLIAM PABOR'S AUTOGRAPH. Pabor's interests were not limited to poetry and song lyrics. He was a relentless promoter of Colorado who edited and wrote for several newspapers and periodicals in the state, including the *Valley Home of Colorado*, *Colorado Farmer*, and *Western Colorado*. Pabor also wrote books on agriculture, including *Colorado as an Agricultural State* and *Fruit Culture in Colorado*, both published in 1883. He was an expert on agricultural irrigation, and a visit to Western Colorado in 1883 convinced him that fruit would thrive in the Grand Valley. This copy of *Colorado as an Agricultural State* was inscribed by Pabor to D. B. Kingsley in Grand Junction in 1883. This was probably Darwin Kingsley, an editor from Vermont who ran a printing company with Edwin Price. (Both, authors' collection.)

D B Kingsley Esq
with the Compliments of
Wm E. Pabor.

Grand Junction
June 23d 1883

EMMA HELME PABOR. William Pabor's third wife bore him four sons and one daughter. His first wife, Phila Ann Waters, died in 1863 at age 22, and his second wife, Elizabeth Meggs Dewey, died in 1866 at age 29. The causes of their deaths are not listed, but the plea "insatiate Archer, would not once suffice?" in Elizabeth's death notice suggests the depth of his pain. (Authors' collection.)

When the wedding bells are rung,
And the marriage service read;
When the bride song has been sung,
And the sweet responses said,
You will know by each sweet token
They are walking, hand in hand,
Now that all Love's vows are spoken,
In the Happy Marriage Land.

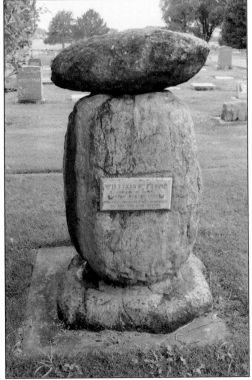

WILLIAM PABOR'S HEADSTONE. For health reasons, William Pabor moved to Florida in 1892—where he founded another town—but he never stopped loving Fruita. Ignoring his doctor's orders, he returned to Colorado and the Grand Valley several times over the next few years, visiting Fruita for the last time in 1910 for the Interurban Railway opening ceremony. He is buried in Fruita's Elmwood Cemetery. (Authors' collection.)

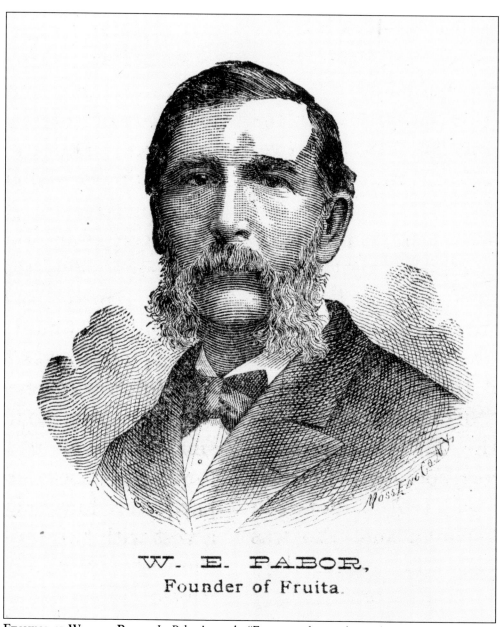

W. E. PABOR,
Founder of Fruita.

ETCHING OF WILLIAM PABOR. In Pabor's words, "Fruita nestles cozily on the broad bosom of the Grand Valley in the shadow of the Great Continental Divide . . . basking in the perennial sunshine of Colorado's cloudless skies. Here the widening valley stretches away to the east and west like a great ribbon, intersected at intervals by a magnificent irrigation system which nourishes a land of wonderful fertility." Pabor died in Denver while visiting friends on August 29, 1911. A front-page eulogy appeared the next day in the *Rocky Mountain News*, stating, "Colorado lost a man who had done much for the commonwealth. A builder and a doer of things, he left his imprint on the state in many ways and his friends are legion." His funeral notice in the September 8, 1911, edition of the *Mesa County Mail* stated, "He loved the Grand Valley, he believed in the Grand Valley, and when he left it for the last time he remarked that although he had traveled all over the United States . . . there was no place to equal it." (Authors' collection.)

14

Two

FRUITS OF THE LAND

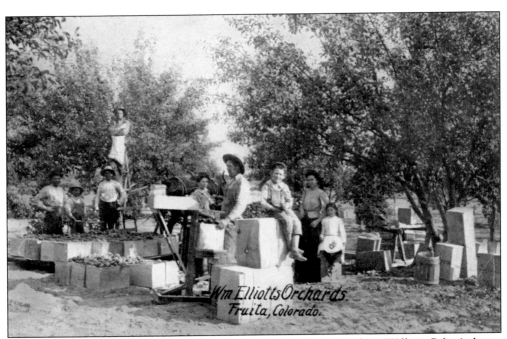

WILLIAM ELLIOTT'S ORCHARD. For a few decades after Fruita's founding, William Pabor's dream of a prosperous agricultural community became a reality. During the first two decades of the 20th century, Fruita became well known for the quality of its apples, such as those produced by William Elliott. Unfortunately, an infestation of codling moths in the 1910s and 1920s finally destroyed the fruit industry in Fruita. (Authors' collection.)

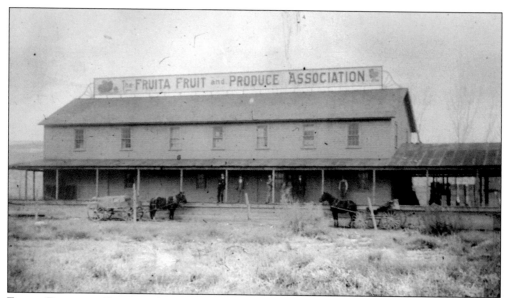

FRUITA FRUIT AND PRODUCE ASSOCIATION. Incorporated in 1904 as a cooperative effort to reduce freight and packing costs for its members, the Fruita Fruit and Produce Association operated a packing and loading shed at the southern end of Mulberry Street. The shed was a bustling place during the fruit harvest season. Apples, pears, and other produce grown in the area were shipped from the shed to Grand Junction, and from there were sent by train to locations all over the country, even abroad. The association was very successful and issued stock, including this certificate issued in 1906. After the apple and pear industry was destroyed, the shed continued to be used for a number of years for other crops grown in the area, including potatoes.

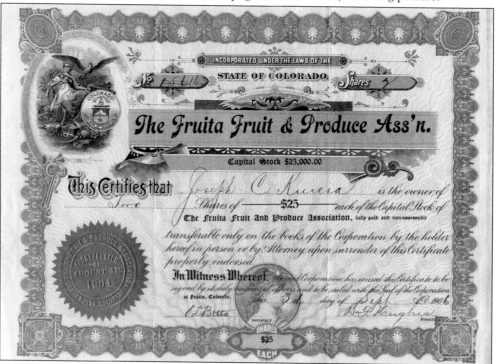

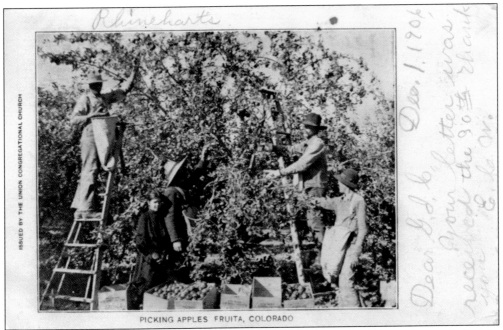

ISSUED BY THE UNION CONGREGATIONAL CHURCH

PICKING APPLES FRUITA, COLORADO

WILLIAM RHINEHART'S ORCHARD. This postcard, mailed in 1906 from Fruita during the height of fruit production in the area, was issued by the Union Congregational Church and shows a group of apple pickers in Fruita. (Authors' collection.)

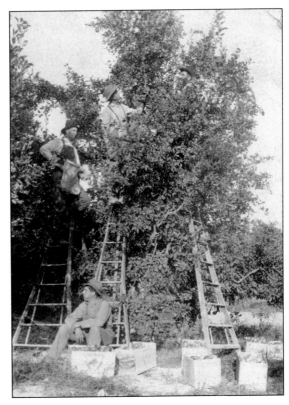

APPLE HARVEST TIME. This real photograph postcard, mailed in 1911, shows apples being picked for the Mesa County Fruita Growers Association, to which many Fruita farmers belonged. Although 1911 promised to be a bumper year for Fruita area apples and pears, the crop was affected by a large hailstorm that passed through the area in early September, damaging the fruit. Losses were estimated at $100,000. (Authors' collection.)

17

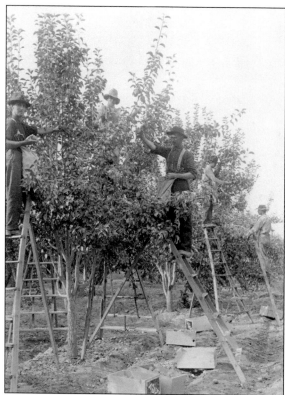

PEAR PICKERS. This photograph of Mesa County agricultural workers picking pears for the Moore's Best label was taken in 1922 or 1923 by the U.S. Bureau of Agricultural Economics for a Bureau of Reclamation report on the Grand Valley Project. Adding to existing irrigation, the Bureau of Reclamation's Colorado River Diversion Dam and Highline Canal began delivering water to the Grand Valley in 1917. (Authors' collection.)

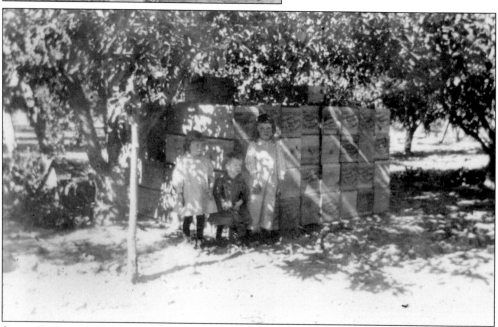

STARR ORCHARD. The Starr family, headed by Fred and Cora Starr, ran a successful apple orchard a couple of miles east of Fruita in Rhone, a farming community that no longer exists. Here, three of their six children—from left to right, Marjorie, Rex, and Velma—stand in front of crates bearing the Mountain Fruit brand in about 1910.

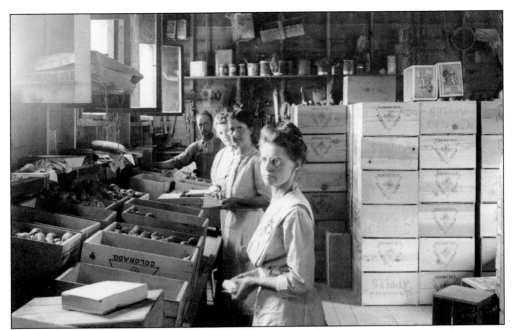

MESA COUNTY FRUIT PACKERS. Taken by the U.S. Bureau of Agricultural Economics for a report on the Bureau of Reclamation's Grand Valley Project, this 1922 or 1923 photograph captures pear packers at work. Most of the apple and pear production in the valley was located in the Fruita area, and many of the area's fruit producers shipped their fruit under the Mountain Lion brand. (Authors' collection.)

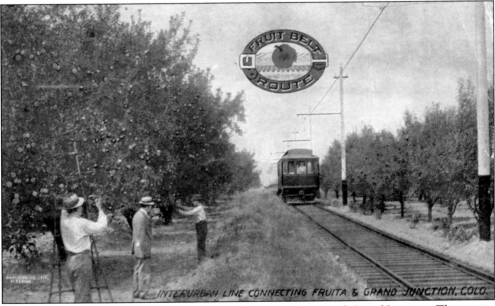

INTERURBAN LINE. An electric trolley operated between Fruita and Grand Junction. The service opened in July 1910 and offered year-round passenger service. The freight service was used by farmers in the area to ship their produce to Grand Junction and operated until 1932. The trip between the two towns took about an hour and meandered along the 15.6-mile "Zig-Zag Route" through orchards and scenic countryside. (Authors' collection.)

19

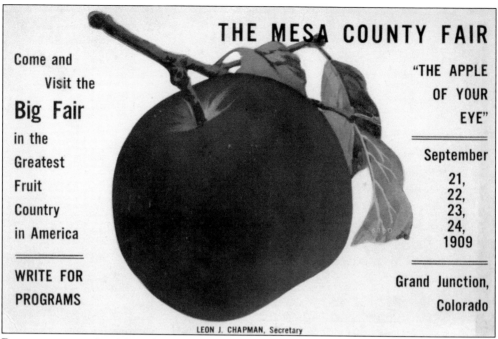

POSTCARD FROM 1909 MESA COUNTY FAIR. This postcard, advertising "the greatest fruit country in America," features a painting of a bright red apple and was mailed from Fruita. On the reverse side, the sender wrote, "This is a very pretty valley and immense quantities of fruit are grown here every year." (Authors' collection.)

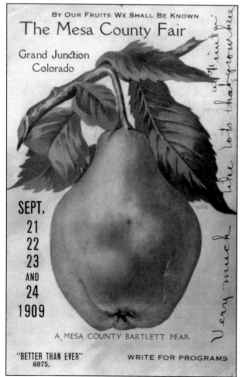

MESA COUNTY FAIR, 1909. The first county fair was held in 1887. Early fruit production in Mesa County was based on apples and pears in the Fruita area and peach and apricot production in Palisade. This postcard was mailed from Fruita and features a Bartlett pear. Next to the picture of the pear, the sender wrote, "Very much like lots that grow here at Fruita." (Authors' collection.)

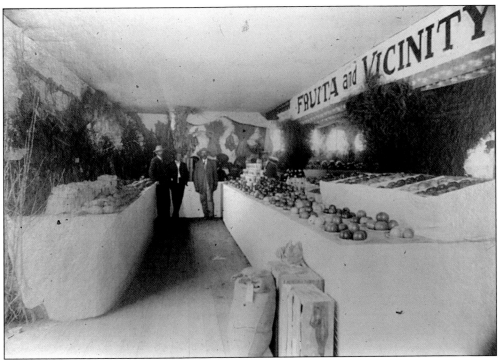

STATE FAIR, 1906. The Fruita and Vicinity booth at the Colorado State Fair held annually in Pueblo featured produce grown in the Lower Grand Valley. Fruita farmer Edwin W. Weckel (third from left), John Carnahan, and two unidentified men proudly displayed their wares, including tomatoes, sugar beets, melons, wheat, apples, potatoes, corn, canned goods, and (perhaps) beans in sacks.

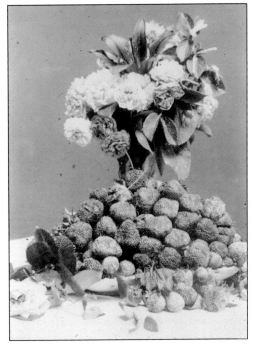

FRUIT DISPLAY, 1910. Strawberries and other soft fruits were also produced by local farmers, including these grown by Newton Pfaffenberger and displayed with flowers at the Colorado State Fair in Pueblo. Soft fruits are more fragile than apples and were mostly grown for local consumption, but Fruita managed to produce good-sized strawberry crops, nevertheless.

21

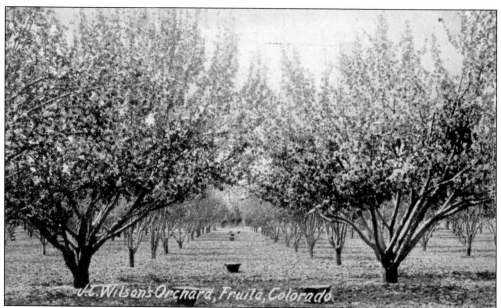

J. C. WILSON'S ORCHARD. In January 1910, the National Apple Exposition was held in Denver, Colorado. The $500 prize for the best carload of apples was awarded to J. C. Wilson of Fruita. The apples were grown on a 2-acre section of his orchard, shown here, on which there were 160 eight-year-old apple trees. The Brown Palace Hotel in Denver purchased Wilson's prize-winning apples. (Authors' collection.)

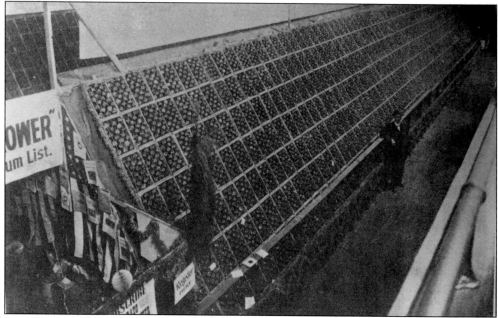

J. C. WILSON'S PRIZE-WINNING APPLES. This photograph of the train carload of Black Ben Davis apples that won Wilson his prize was featured in a 1910 booklet issued by the Fruita Chamber of Commerce promoting Fruita as an ideal place to make a home and make a profitable living growing fruit. Fruita and Mesa County's showing at the National Apple Exposition was the zenith of Pabor's vision of a fruit-producing community.

PORTRAIT OF MABEL SKINNER.
Fruita was very proud when one of its citizens, Mabel Skinner, was chosen as the National Apple Queen in January 1910 in a ceremony in Denver during the National Apple Exposition. She won a $200 dress and a $150 ring as her prizes. She was crowned by Colorado governor John Shaforth. Upon her return, several dinners and events were held in the community to honor her.

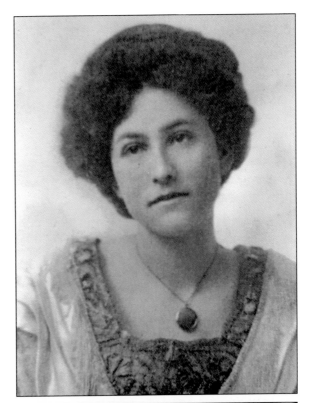

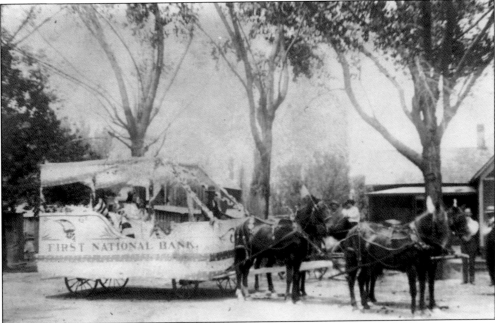

FRUITA QUEEN APPLE FLOAT. Before the National Apple Exposition, the town of Fruita held the Fruita Queen Apple Festival to select their entrant in the National Apple Queen Competition. Mabel Skinner was chosen queen of the festival and is shown here on the First National Bank float that headed the parade. She then went on to Denver to represent Fruita.

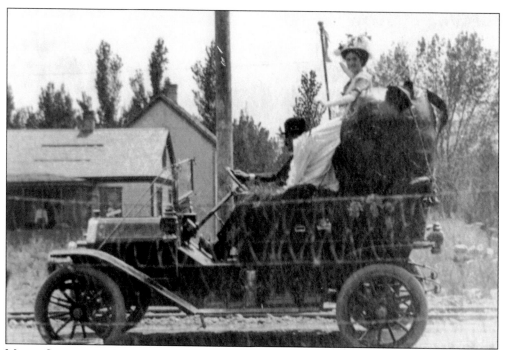

MABEL SKINNER AS APPLE QUEEN. The 1910 Apple Exposition won Fruita and Mabel Skinner a great deal of publicity. Upon her triumphant return to Fruita, a parade was held in her honor. Mabel is pictured sitting high atop her apple-shaped throne in a 1910 E-M-F 30, a right-hand drive, 30-horsepower, four-cylinder, five-passenger touring car.

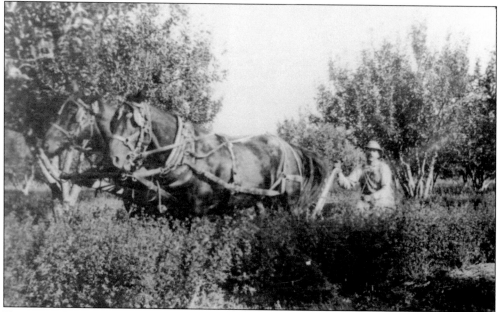

FARMER IN ORCHARD. Although this Fruita farmer is cultivating fruit trees, he is also doing double duty by growing alfalfa between the rows of trees. He and his horse-drawn team are shown here preparing to mow the alfalfa. As a legume, the alfalfa would fix the nitrogen in the farmer's orchard, improving its productivity, and after mowing could be used or sold as feed.

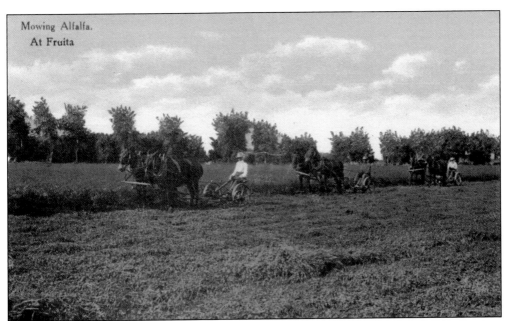

Mowing Alfalfa.
At Fruita

MOWING ALFALFA. Although most of Fruita's agricultural industry was focused on fruit production, the expansion of irrigation opened the area to all types of farming. Sugar beets, potatoes, alfalfa, and oats were all excellent cash crops in the area. The alfalfa these farmers are mowing makes a highly nutritious livestock feed, and in this climate several crops can be grown per year. (Authors' collection.)

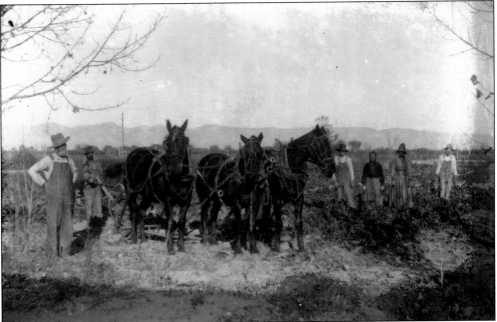

AGRICULTURAL WORKERS. After apples, sugar beets were the most profitable crop in the Fruita area. This photograph of beet farmers and their team of horses was taken in 1913. Sugar beets are being gathered for shipping to the beet sugar factory in Grand Junction. The factory, which opened in 1898, gave area farmers a ready destination for sugar beets.

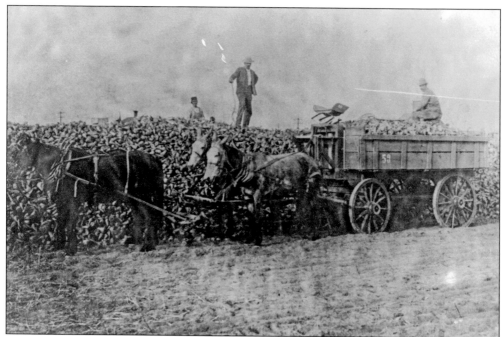

SUGAR BEETS. Local beet growers are shown loading their crops onto wagons to be shipped from Fruita to Grand Junction. For several decades in the early 20th century, beet sugar production was one of the biggest industries in the Grand Valley. As a production byproduct, the beet sugar factory supplied ranchers and farmers with silage for livestock.

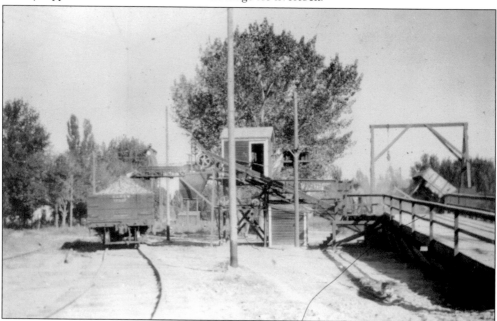

SUGAR BEET DUMP. Thousands of acres of sugar beets were grown on local farms and shipped from the local Denver and Rio Grande Railroad stop, shown here. In 1907, for example, Fruita shipped about 80 railroad cars full of beets. The beets were sent to the beet sugar factory in Grand Junction to be processed.

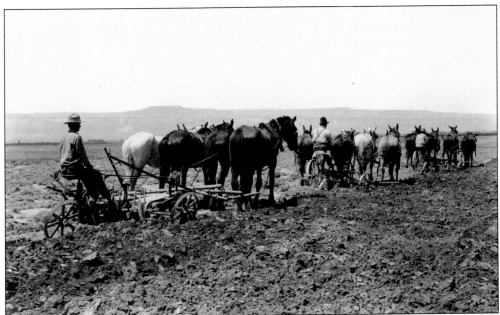

HORSE-DRAWN PLOWING TEAMS. Nearly every agricultural endeavor begins with breaking the earth. This photograph of three plow teams of Fruita area farmers preparing their field was taken in 1922 or 1923 by the U.S. Bureau of Agricultural Economics for a report on the Grand Valley Project for the Bureau of Reclamation. The ever-present Colorado National Monument towers in the background. (Authors' collection.)

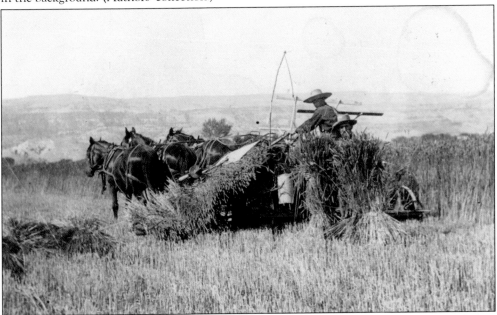

HARVESTING WHEAT ON WECKEL'S FARM, 1906. Other crops were also grown locally, including wheat. In 1909, Edwin Weckel won a gold medal—the first prize—for a homegrown strain of fall wheat he called Weckel's Bearded King at the National Corn Exposition in Omaha. His farm was located at the western edge of Fruita, and his house is listed on the Colorado State Register of Historic Properties.

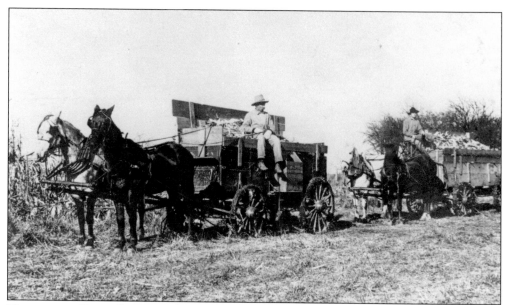

HARVESTING CORN. Corn was also grown in the Fruita area, although not in large quantities. These workers are loading their horse-drawn wagons with corn to sell at local markets. Most corn was grown for local consumption but was sometimes also grown and sold for livestock feed.

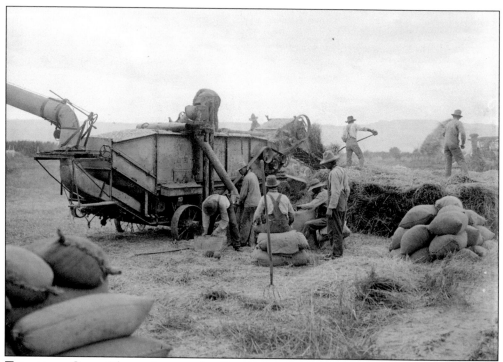

THRESHING OATS. The workers on this Fruita area farm are using a threshing machine to mechanically separate the edible part of their oat harvest, the groats, from the inedible straw and chaff. This photograph was taken in 1922 or 1923 by the U.S. Bureau of Agricultural Economics for a report on the Grand Valley Project for the Bureau of Reclamation. (Authors' collection.)

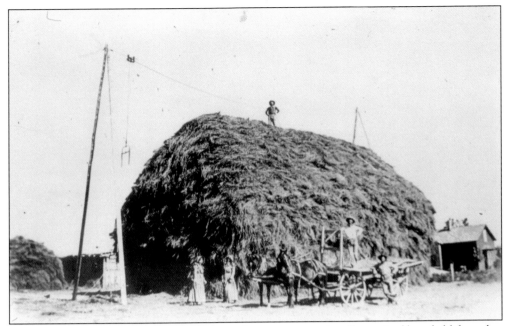

A MOUNTAIN OF MONEY. Edwin Weckel stands atop a mountain of hay raised by a forklift stacker with a double harpoon fork on William Schwartz's farm. Schwartz stands on the wagon. The photograph was originally given the caption used here when it was featured in a 1910 booklet issued by the Fruita Chamber of Commerce.

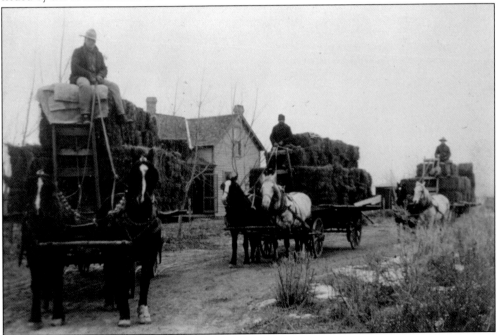

HAY WAGONS AT LEONARD FINCH'S PLACE. This photograph taken sometime in the early years of the 20th century shows horse-drawn wagons loaded with hay. Given the snow on the ground, the hay is probably being brought out from storage to be used as winter feed for cattle or horses. The wagons are specifically designed for the transportation of hay bales.

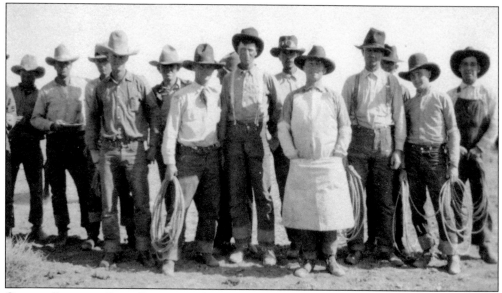

COWBOY ROUNDUP BOYS. Starting in the early years of the 20th century, a cowboy roundup was held each year in the desert rangeland about 20 miles north of Fruita. Local livestock ranchers, herders, horse wranglers, and cowboys from the various ranches, as well as independents looking for work, would gather for several days in May to swap stories, share meals, and conduct business. This was no rodeo, however. Thousands of heads of cattle were rounded up at the event to be separated by their brands, counted, branded, and sold. These photographs of the cowboys and the camp cook (above) and cowboys at the mess wagon (below) were taken at the 1923 roundup.

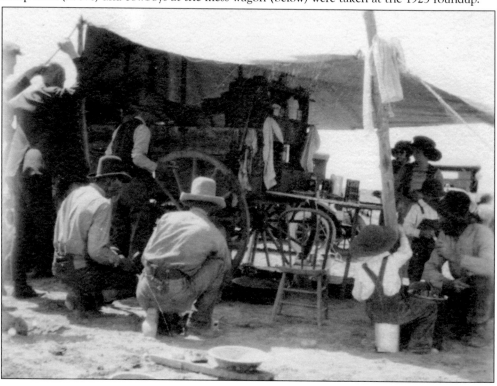

YOUNG COWBOYS AT THE ROUNDUP. These boys joined their fathers at the Fruita Cowboy Roundup in May 1923. It was great adventure for the kids, and the roundup wagon had good food that included baking-powder biscuits, beef, dried fruit, potatoes, rice, and bread pudding, so everyone got plenty to eat and the ranch women did not have to cook for a meal or two.

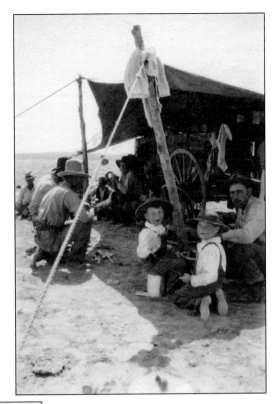

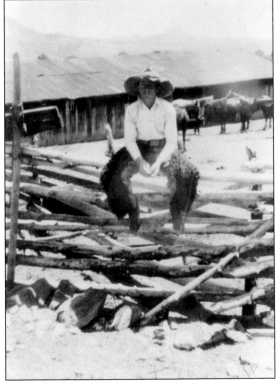

RANCH WORKER. Glen Austin worked with horses at the Flying W Ranch in 1928 or 1929. The Flying W, owned by the Turner family and located about 30 miles north of Fruita, was known both for its cattle and its sheep, an unusual arrangement. The Turners lived at the ranch during the summer and in the town of Fruita during the winter so the children could attend school.

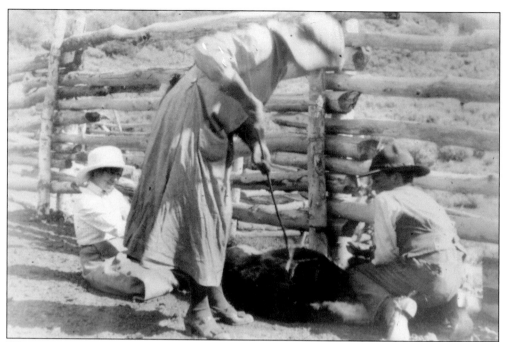

WOMEN ON THE RANCH. Ranch life was not an easy calling for women, as shown in these photographs taken during the 1910s. In addition to performing the daily domestic chores and childcare common to most women of the time, ranch women were burdened with special duties. Livestock had to be cared for, gardens had to be tended, chickens raised, and animals slaughtered. Cooking was usually done over a wood- or coal-burning stove that required regular cleaning to prevent fires. Canning food was not a hobby but a necessity for survival. Condiments like ketchup were usually homemade, as were pickles, jams, bread, and a host of other foodstuffs. Even soap was often homemade. The woman in the photograph above is shown branding a calf with the assistance of her children, and the women below are washing their clothes in buckets.

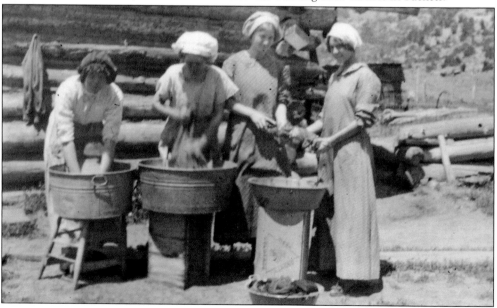

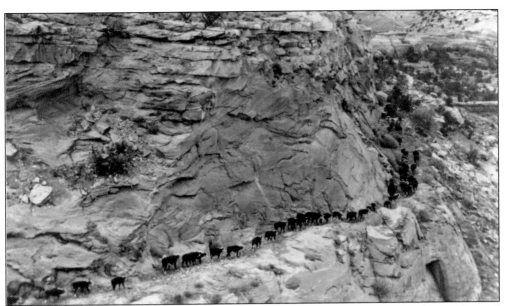

THE FRUITA DUGWAY. Many of the ranches and livestock summer grazing lands were located on Piñon Mesa (near Glade Park), about 25 miles south of Fruita. Travel between Piñon Mesa and Fruita was a treacherous undertaking that took place along a steep and narrow path called the Fruita Dugway that had been carved out by hand starting in the 1880s. The travel was necessary, however, because sheep and cattle ranged in the desert areas in the winter and the high country during the summer. The top photograph shows cattle traveling along the dugway, and the bottom photograph shows sheep being herded along in the aspen forests atop the mesa. Fresh water for Fruita came from Piñon Mesa, and the wooden water pipes carrying it were laid along the dugway.

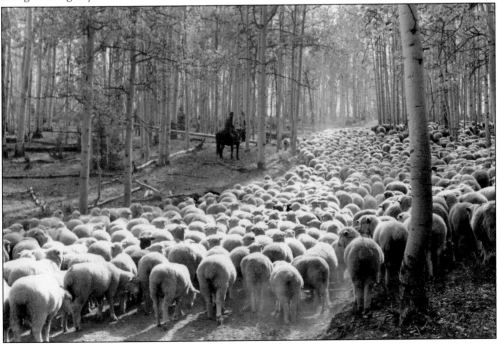

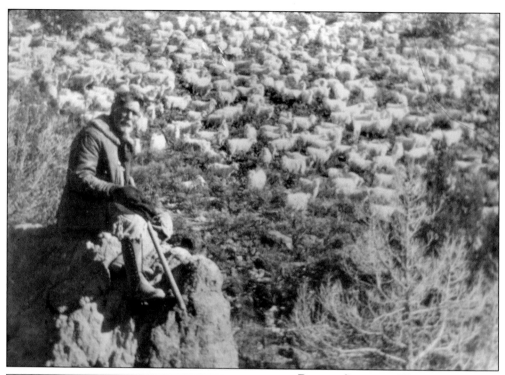

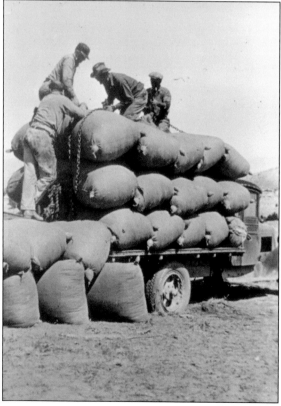

BASQUE SHEPHERD TENDING HIS FLOCK. Cattle and sheep were both ranched locally, although not always without conflict. These sheep were owned by the Flying W Ranch, which had started out as a cattle outfit but branched into sheep a decade or so later. Many of the shepherds hired by the sheep outfits originated from the Basque region of Spain.

BAGS OF WOOL. These local sheep ranchers are getting ready to take their wool to Fruita to send it to market in this photograph taken during the 1930s. Sheep ranchers had two big paychecks each year—when the sheep were sheared in the spring and when the lambs were sent to market in the fall.

Three

FULL CIRCLE
AROUND THE SQUARE

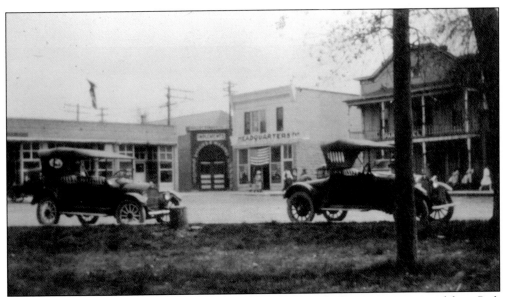

SOUTHEAST CORNER OF SOUTH PARK SQUARE. Fruita's business district grew outward from Park Square. Bronk Park, sitting at the square's center, was also originally square but was reshaped as a circle in the first decade of the century to accommodate traffic. Both automobiles in the foreground of this photograph appear to be Dodges from around 1918–1920. Behind them sits Valley Commercial Company, which sold buggies, wagons, feed, seed, coal, and related necessities.

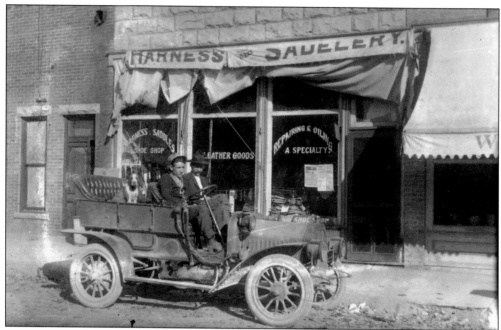

HARNESS AND SADDLERY IN 1913. Michael Fromm made shoes and other leather goods, oiled saddles, and offered harness repair "by first-class harness men." His saddlery shop (misspelled as sadelery on the awning) was located on the southeast side of Park Square. In the photograph above, Fromm is seated behind the steering wheel in the 1908 Buick Model F Touring Car, a right-hand drive, chain driven, two-cylinder rig with the engine under the front seats and the gasoline tank under the hood. The base price was $1,250, with windshields and tops costing $50 and $100 extra, respectively. William H. West's Hardware is to the right. The interior of the shop, with its prominent display of buggy whips, can be seen below. Fromm is the second man from the left.

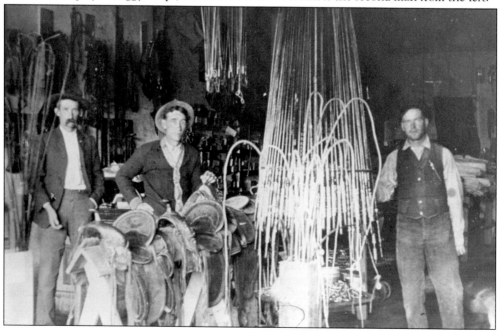

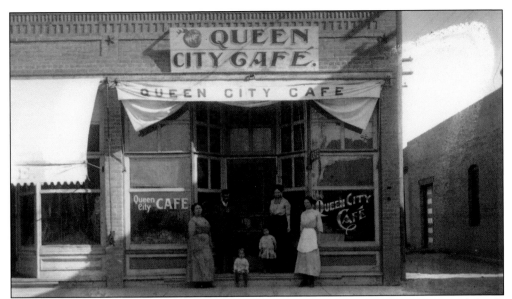

QUEEN CITY CAFÉ IN 1913. Named for Mabel Skinner, who had been named National Apple Queen in 1910, this café was located in the southeast section of Park Square. The proprietor, Mrs. Cooper, specialized in "dinners and suppers for lodges and other organizations," chili, oyster stew, fresh doughnuts, and pies. William H. West's Hardware is to the left. This and both buildings north were demolished later in the century.

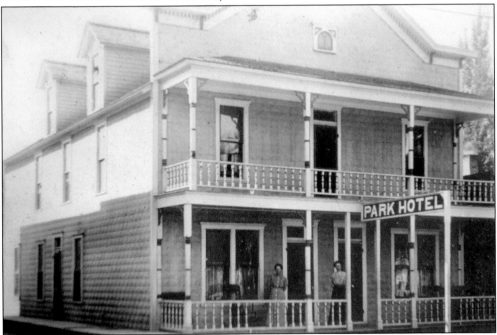

PARK HOTEL EXTERIOR, C. 1900. The hotel was founded in the early years of the 20th century by William and Mary Anne "Mae" Pollock. Although Mae Pollock was soon widowed, she continued to run the hotel herself until her death in 1915. Afterwards, her daughter-in-law, coincidently named May, took over. Many famous locals stayed at the Park Hotel, including Chief Ouray's wife, Chipeta, who enjoyed sitting on the porch swing.

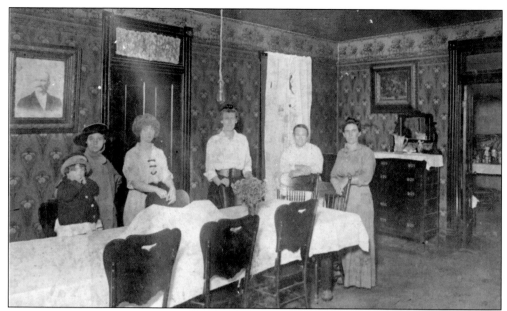

PARK HOTEL DINING ROOM, C. 1905. From left to right, Joseph; Bessie; and Irma Dalley; their mother, Margaret; her mother, Mae Pollock; and an unidentified woman (possibly Pollock's daughter Jennie Hay or daughter-in-law May) gather around the table. Mae was known for her cooking, especially her cakes. Even after her death, the dining room was popular with locals, until ill health forced daughter-in-law May to close it in about 1939.

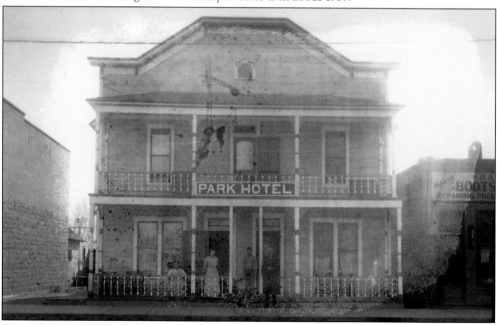

PARK HOTEL IN 1913. While there is currently a bicycle shop in the building's first floor, the upstairs is still the Park Hotel, making it the oldest business in Mesa County still in the same location and operating as the same continuous business. Mae Pollock (seated) and her daughter Margaret Dalley are on the front porch. The men are unidentified but are likely Margaret's son and husband, both named Joseph.

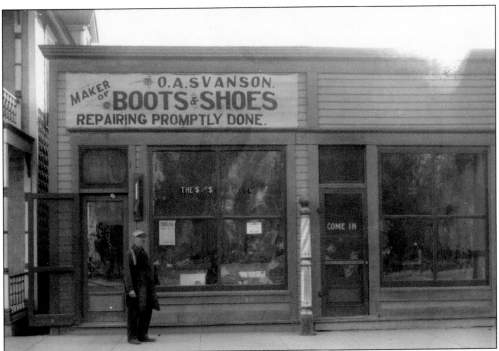

O. A. Svanson Boots and Shoemakers. Olaf A. Svanson was a cobbler who made and repaired boots and shoes in his shop on the southeast side of Park Square, immediately west of the Park Hotel. Svanson operated his shop until his death in 1921. He posed outside his business in this photograph taken in 1913.

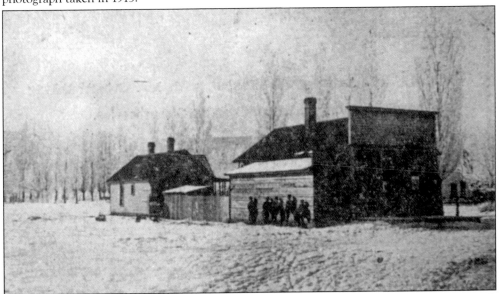

Dr. Beard's Drug Store, 1895. While Dr. James M. G. Beard, who arrived in Fruita in 1895, was preceded by Dr. Charles Masser in 1888 and Dr. Williams before that, he built Fruita's first drugstore and first hospital. This photograph of Dr. Beard's practice and store on the southeast corner of Park Square and South Mesa Street, where the thrift shop is now located, was taken before he built his hospital.

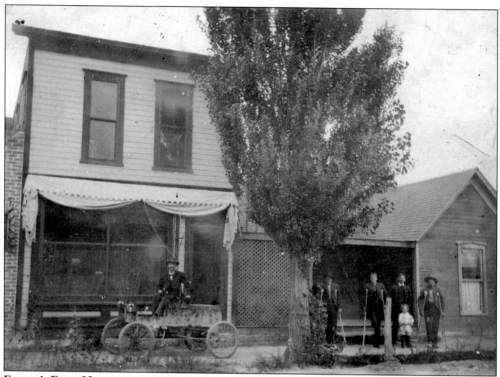

FRUITA'S FIRST HOSPITAL, C. 1910. Dr. James Beard poses in his electric car with several patients and Dr. Robert Benjamin Porter (far right, no crutches) in front of his office (downstairs) and four-bed hospital (upstairs) immediately south of his drugstore. Dr. Beard's hospital closed after his death in 1912. In 1914, a practical nurse, Hattie Sayles, opened a new hospital, Cloverlawn Sanitarium, at North Coulson Street and West Pabor Avenue.

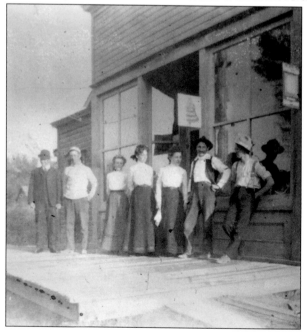

GROUP IN FRONT OF DR. BEARD'S PHARMACY. Beard and Son's Drug Store was established in 1895 and was Fruita's first pharmacy. Fruita's first telephone exchange was also located there. This photograph was taken by Minnie Hiatt around 1900. Standing from left to right are John Davis, John Beard, Maud and Helen Williams, Nell Sperry, James Nichols, and Edgar Beard.

DR. BEARD'S X-RAY MACHINE. In addition to his medical practice, Dr. Beard operated an X-ray machine factory. The machine pictured utilized a hand-cranked generator to energize the X-ray tube. According to the *Fruita Times* in October 1959, "An open X-ray tube such as this would be looked on with horror by today's X-ray specialists, but pioneers in the field were unaware of the dangers to which they exposed themselves."

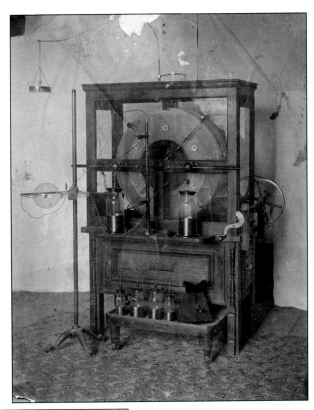

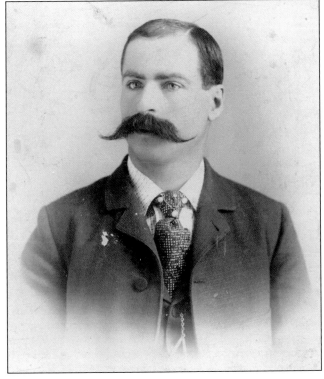

GEORGE NEWBURY. Newbury was the builder of the X-ray machine produced in Dr. Beard's X-ray factory, the man who took Dr. Beard's patents and made them real. Newbury also built Dr. Beard's telescope and observatory and his electric car, the first car in Fruita, and he opened a repair shop with Dr. Beard's son John, another devotee of mechanics and electrical devices. Newbury later operated the Fruita Garage.

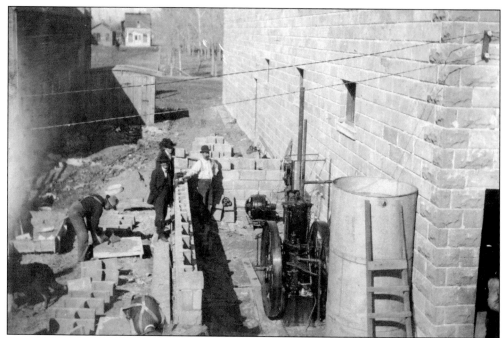

FIRST BANK OF FRUITA CONSTRUCTION. The First Bank of Fruita building was built in 1904, and its southeast end housed a number of businesses, including the Fruita Post Office. This photograph shows the construction of the pump and cistern house used to provide the bank with water before the water pipeline from the Fruita reservoirs was completed in 1907. The man in the bowler hat is George Newbury.

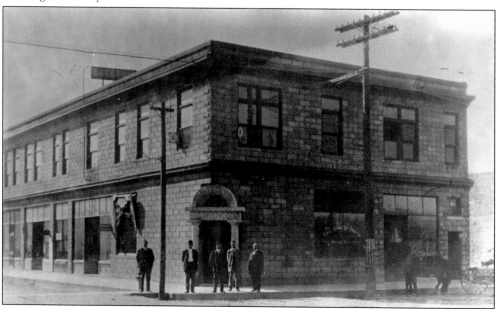

FIRST BANK OF FRUITA. This bank, photographed in 1913, was located on the southwest corner of Mesa Street and Park Square. The bank was established in 1904 and remained in business until 1927. The bank president was Wallace A. Merriell, who at the time also ran a lumberyard and hardware store with Oscar J. Bolinger.

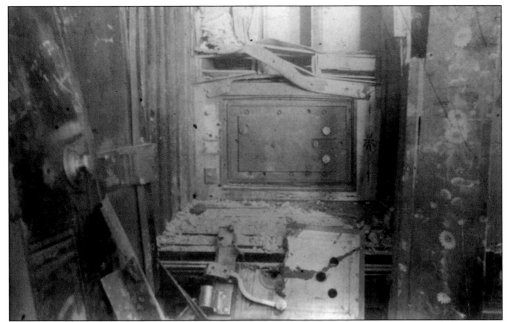

BANK OF FRUITA ROBBERY, 1905. Early in the morning on May 13, 1905, robbers blew open the outer doors of the vault at the First Bank of Fruita, after having earlier blown open the safe at the Fruita Mercantile Company and robbed it. Witnesses heard the second explosion, and the telephone exchange called the bank. The alarmed burglars fled before they could open the inner doors and rob the vault.

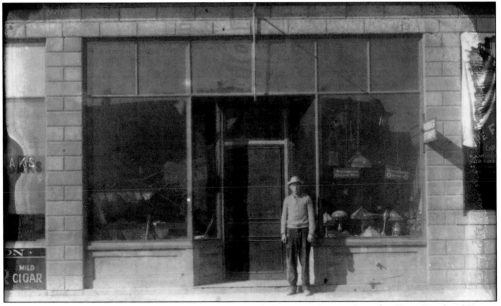

FRUITA ELECTRICAL SHOP IN 1913. The electrical shop was located in the First Bank of Fruita building on South Mesa Street. The man is proprietor John G. Beard. The shop sold Westinghouse motors, lamps, and other electrical devices. The store was advertised by the first known electrically lit sign in Fruita, which can be seen in the photograph on the opposite page mounted high on top of the bank building.

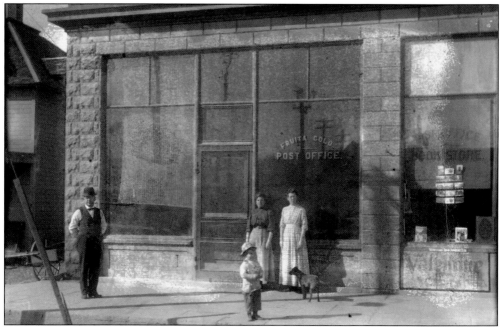

FRUITA POST OFFICE. The post office, photographed in 1913, was located on the west side of South Mesa Street, just south of Park Square in the First Bank of Fruita building. Allison's Post Office Bookstore was located next door to the post office on the right side. The building in silhouette immediately south is the Nichols Hotel.

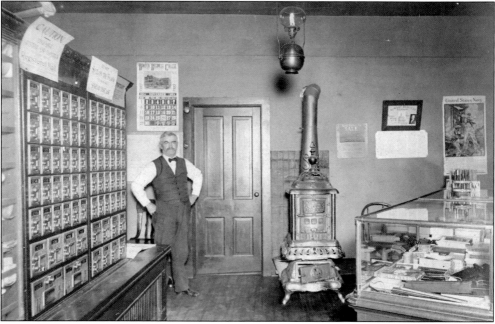

POST OFFICE INTERIOR. According to the calendar on the wall, this photograph was taken in November 1914. A sign on the wall above the post office boxes instructs patrons not to spit on the floor, "to do so may spread disease." The postmaster at this time was Andrew V. Sharpe, who also ran a real estate agency.

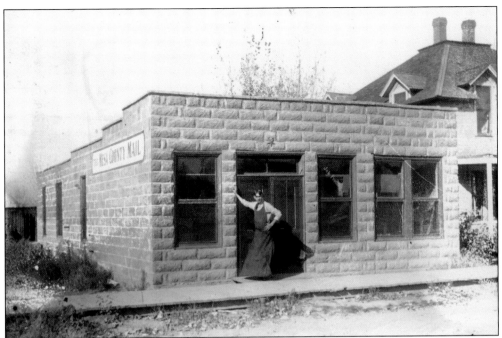

MESA COUNTY MAIL BUILDING, 1913. The *Mesa County Mail* was started by Benjamin and Frank Kiefer, founders of the town of Cleveland (annexed to Fruita in 1905) and vital canal builders. The *Mail* had many homes over the years, including this concrete block building on South Mesa Street, immediately south of the Nichols Hotel. The building had previously housed another newspaper, the *Fruita Telegram*, a weekly first published in 1906 that the *Mail* bought in 1909. The Thursday, December 19, 1907, *Fruita Telegram* included the following verse: "When I am weary, tired and sad / When things are going to the bad, / When no relief seems to be had / And Life looks like a sham: / I don't give up, not I indeed, / I know it's tonic that I need / And so I sit me down and read / *The Fruita Telegram.*"

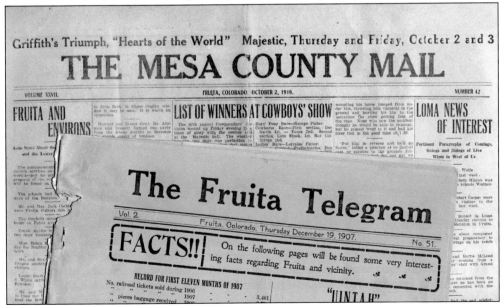

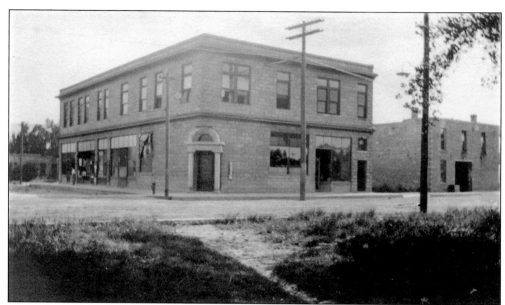

FIRST BANK OF FRUITA BUILDING. This shot of the bank building taken from the park shows the shops on South Mesa Street on the left, the bank entrance in the center, and the bank offices on the right of the building. The Nichols Livery Stable is the smaller building on the right.

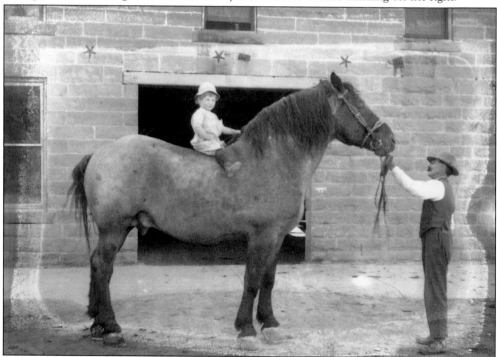

BOY ON HORSE. Stephen Nichols, who arrived in what would become Fruita with his brother James in 1883, ran the Nichols Livery Stable on the southwest side of Park Square. He holds the reins and his son sits astride the horse in this 1913 photograph. Nichols also ran the Nichols Hotel, which sat between the *Mesa County Mail* building and the post office in the First Bank of Fruita building.

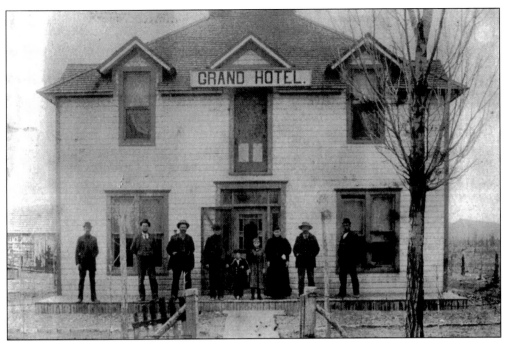

THE GRAND HOTEL. Thought to be the first hotel in Fruita, the Grand was located on North Park Square, on the west side, facing east, where the post office now stands. The photograph was taken sometime in the late 1880s or the 1890s. The hotel was built by Louis Overcamp.

FRUITA HOTEL. This hotel was located on the northwest corner of Park Square. During its history, the hotel was also known as the Owens Hotel and later as the Bagshaw Hotel and Livery when it was run by Joseph Bagshaw.

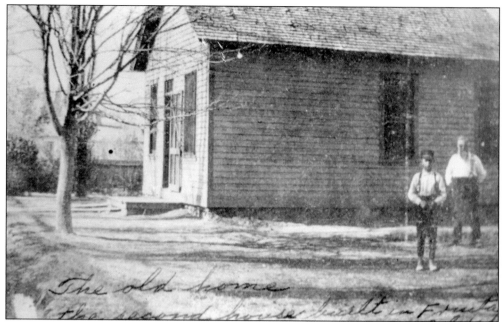

SQUIRE LANE'S HOUSE, C. 1900. Squire G. Lane, the first official postmaster, built the second house in Fruita, which was also the first frame house. He lived there with his grandson, Lee L. Travis (both pictured), and ran the post office from it. The house, with the addition of a front porch and extensions at the rear, remains standing today on North Mesa Street, opposite the Lower Valley Fire Department.

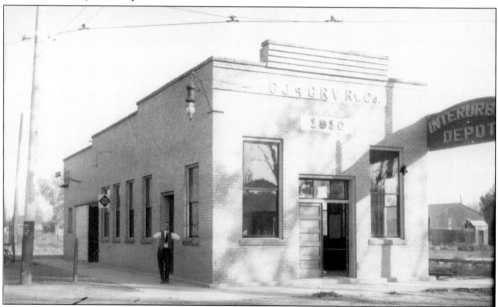

INTERURBAN DEPOT. The depot was constructed of yellow brick at the corner of East Pabor Avenue and North Mesa Street, where the fire station currently stands. A schedule published in 1910 lists 12 trips each weekday from Fruita to Grand Junction and 12 trips back. Clyde Scoles was one of the operators, and he later ran the Public Service utility company office out of the same building.

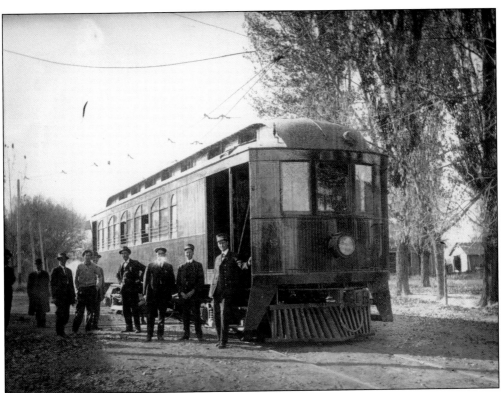

INTERURBAN TRAIN CARS. In Fruita, the Interurban train traveled down East Pabor Avenue to the depot on the corner of East Pabor Avenue and North Mesa Street. The wooden carriages were made by the Woeber Carriage Company in Denver. Woeber made trolley cars for trolley systems in Denver and several other western cities. The first train car was 40 feet long and weighed 24 tons. The photograph above was taken by Minnie Hiatt in 1913 and shows the conductors and several townspeople, including John G. Beard in the sweater. The photograph below was taken by Pearl Roach, probably in 1911. (Below, Authors' collection.)

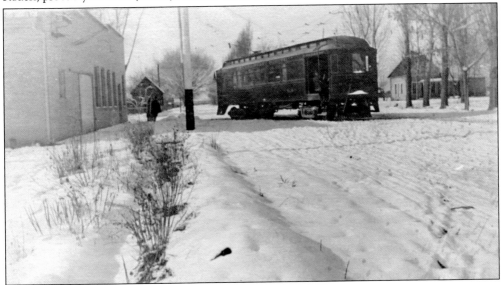

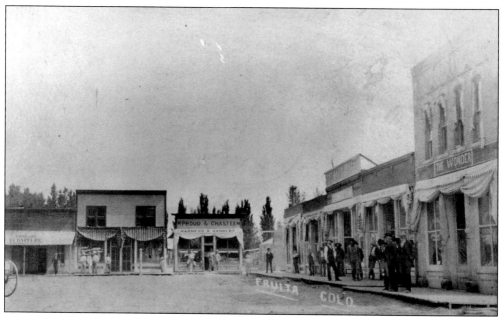

NORTHEAST PARK SQUARE IN 1906. From left to right the businesses are T. S. Phillips Furniture, Nichols' Restaurant, Clarence Smyser's barbershop, McProud and Chasteen's Harness and Saddlery Shop, the Fruita Mercantile Company, and the Wonder Store. The building housing the Wonder was extensively remodeled in 1912 to become the First National Bank of Fruita. The Wonder's window signs indicate they sold boots and shoes, ladies' furnishings, hay, and groceries.

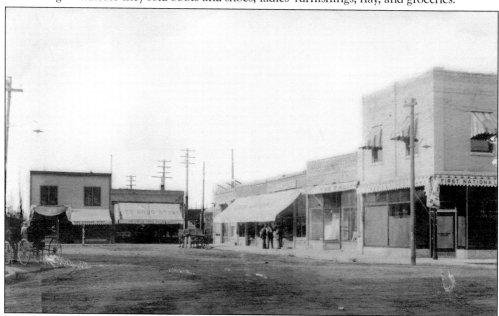

NORTHEAST PARK SQUARE, 1912–1916. From left to right is the City Drug Store operated by Dr. Elizabeth T. Adams; the City Barber Shop operated by John H. McWilliams (Smith Kilby after 1916); the Fruita Mercantile Meat Market and Grocers operated by George Finnicum; an empty storefront that became the Fruita Mercantile Hardware Store around 1917; and the First National Bank of Fruita, which moved to this location in 1912.

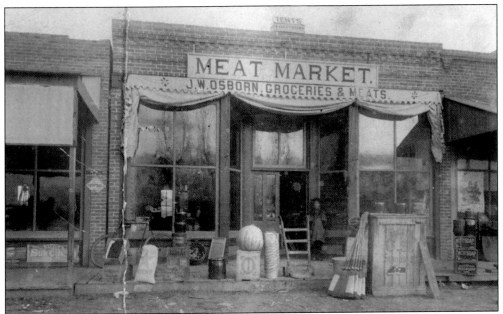

OSBORN GROCERIES AND MEATS. Jesse W. Osborn and his family moved to Mesa County in 1886. He founded J. W. Osborn Groceries and Meats on North Park Square in 1892. He sold out and moved in 1896, but his eldest son, Carl, returned in 1901 to cofound the Fruita Mercantile Company. Jesse's daughter Pearl stands in this undated photograph; her apparent age and 1885 birthday dates the picture to around 1895.

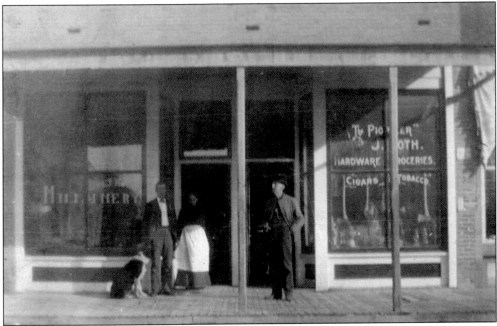

ROTH PIONEER STORE. Joseph Roth ran a grocery and dry goods store, which also contained his wife Iris's millinery and ladies' furnishings store, from 1895 until at least 1907. The store occupied a brick building on the east side of the northeast corner of North Park Square. Their daughter, Pearl, who took the photograph, later ran a millinery similar to her mother's called the Vogue.

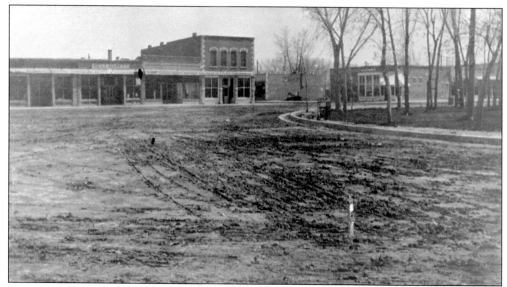

NORTHEAST PARK SQUARE PANORAMA, C. 1910. The left awning banner reads "Plumbing, Heating, Hardware, Meats, and Groceries," and the sign above reads "Meat Market." The right awning banner reads "Dry Goods, Shoes, Notions, and Millinery and Ladies' Furnishings." This is the Fruita Mercantile Company, owned by William Carl Osborn and William T. Brumbaugh, before they broke the Fruita store into three units around 1911.

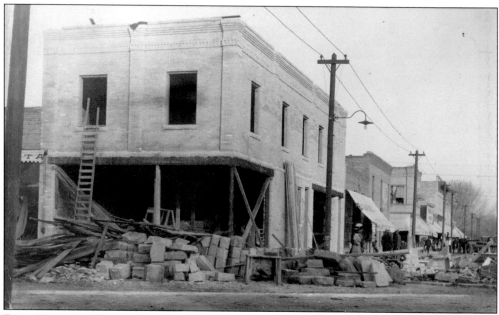

FIRST NATIONAL BANK UNDER CONSTRUCTION. This image shows the exterior of what is today known as the Mid-Valley Building in 1911. The building was undergoing reconstruction so the First National Bank of Fruita could be moved there from its original location at the corner of East Aspen Avenue and South Mulberry Street. After the extensive remodeling, the bank moved to the new location, where it remained until December 31, 1934.

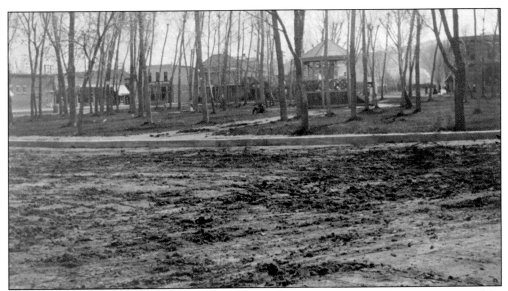

SOUTHEAST PARK SQUARE PANORAMA, C. 1910. Although the streets would remain unpaved for decades, Fruitans had already rounded the original square park to better accommodate traffic and had added concrete curbing to define its borders. Concrete sidewalks had replaced earlier wooden boardwalks, and drains and sewers were being installed. Telephone service existed, but electric power would not arrive until after power lines for the Interurban were run from Grand Junction.

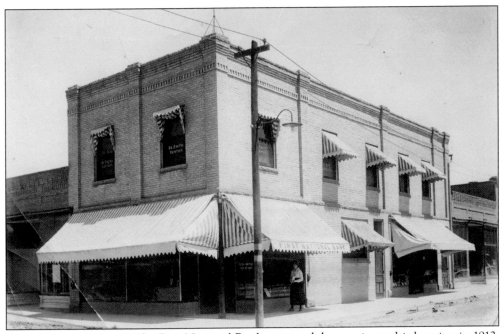

FIRST NATIONAL BANK. The First National Bank reopened downstairs at this location in 1912. This photograph was taken in the 1920s. Over the years, the upstairs has been home to a variety of businesses, including several medical and dental offices. The bank finally closed when it was purchased in 1934 by the First National Bank of Grand Junction.

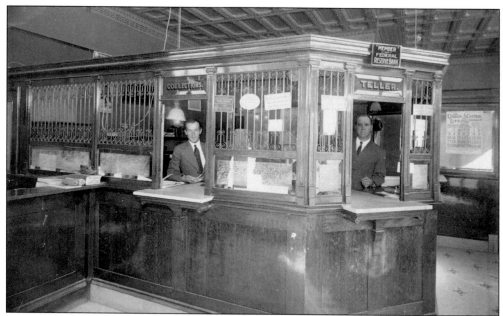

First National Bank Interior, 1915. Lee Warner stands at the collections window and Leonard A. Stewart stands at the teller window in this October 1915 photograph taken inside the First National Bank of Fruita. Although the fine quarter-sawn oak cage has long since disappeared, the heavy steel safe remains today, and the mosaic tile lies under the current occupant's carpeting.

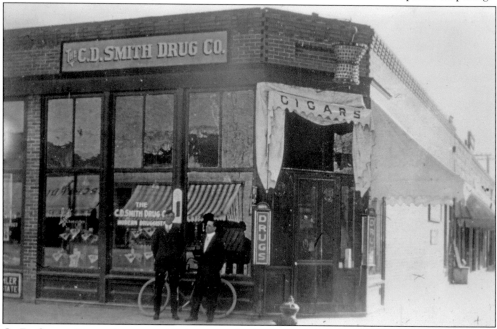

C. D. Smith Drug Company. This store, which was established about 1902, was located on the southeast corner of East Aspen Avenue and South Park Square. Signs advertise such items as cigars and Liggett's Chocolates. The mortar and pestle above the door appears to be set with colored glass beads. The building burned October 14, 1927, and the store was moved to the Masonic building. Fred Young stands at left.

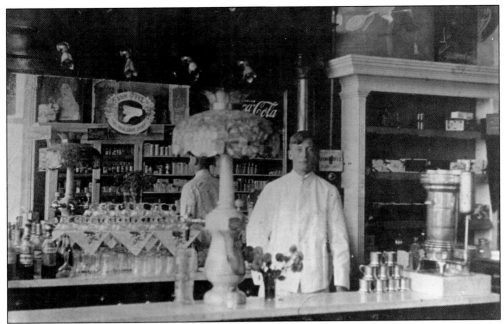

C. D. Smith Drug Company Interior. In the above photograph, Fred Young poses at the soda fountain. The photograph below shows another drugstore employee, Mr. Myers. Interior product advertisements include Horlick's Malted Milk, Mentholatum, Red Raven Splits, Kondon's Catarrhal Jelly, Sanitol Tooth Powder, a deafness treatment, and Rexall. The drugstore was one of seven stores in the C. D. Smith chain of stores in the Grand Valley and was operated in 1913 by Larkin Leonard Raber. Raber eventually purchased the drugstore from C. D. Smith and renamed it the Fruita Drug Store. Raber continued to operate the store, even after the fire and subsequent relocation, until 1944.

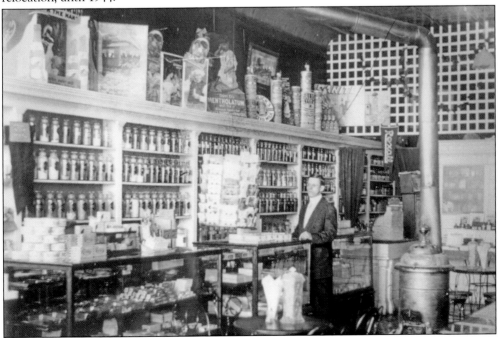

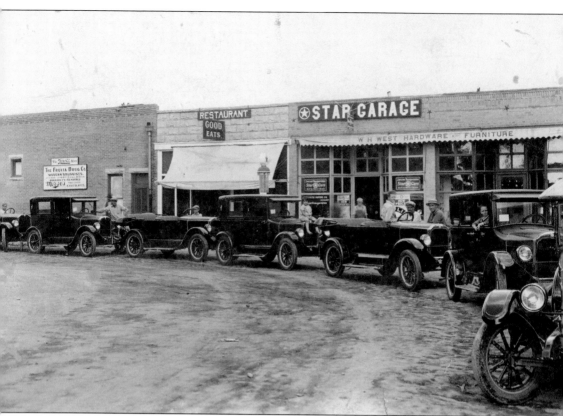

Star Garage, 1926. This image shows several businesses at the southeast corner of Park Square, including the Fruita Drug Company, a restaurant, and the Star Garage. The awning over the garage reads W. H. West Hardware and Furniture and is left over from William H. West's earlier business. The Star Garage, owned by William Roberts, was also known as Roberts Motor Company, and they sold Star automobiles, which was the lower-end sister line of Durant Motor Company designed to compete with the Ford Model T. Four examples of the 1926 Model F are displayed. From left to right are a touring car, base price $540; a brougham, base price $750; another touring car; another brougham; another touring car; a sedan, base price $820; and a special touring car, base price $690. Note also the Texaco Star globe on the gravity-fed visible gas pump in front of the garage.

Four

UP AND DOWN
THE AVENUE

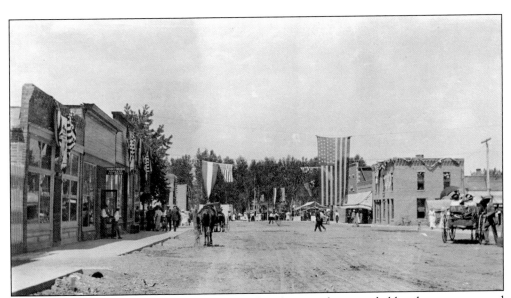

LOOKING WEST DOWN EAST ASPEN AVENUE. This photograph was probably taken on or around Independence Day in 1908 or 1909. The buildings on the south side of the street are visible, but the Beach Block building, built in 1910 on the north side of the street, is not yet in existence. Flags and bunting are out in readiness for a parade or carnival.

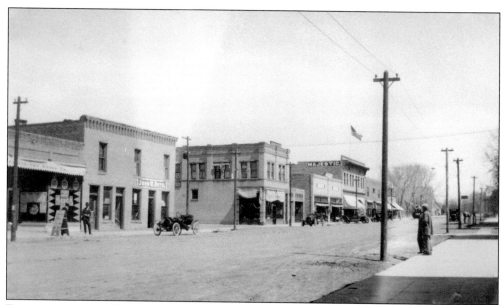

EAST ASPEN AVENUE LOOKING NORTHEAST. The center of commerce in Fruita was located on East Aspen Avenue. The photographer, Fred Fraser, or his wife, Carrie, is standing on the southwest corner of Aspen around 1917 looking up the street at the business district. The businesses at left are the Fruita Dry Goods Company and John Roth's real estate office. The Majestic sign on the theater is visible down the street.

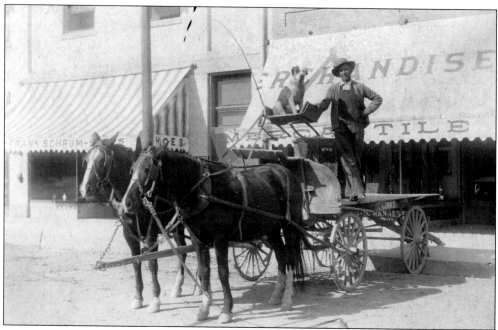

FRUITA MERCANTILE DOMESTIC STORE. William Roach and his dog Ted pose on his wagon in front of the Fruita Mercantile domestic goods store in about 1913. The photographer was Roach's wife, Pearl, a well-known local photographer. This unit of the Fruita Mercantile Company, next to Frank Schrum's shoe store in the First National Bank building, sold clothing, dry goods, and other domestic items, including Majestic kitchen ranges.

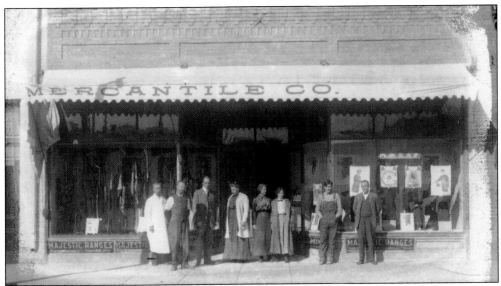

THE MERCANTILE BRANCHES. Around 1911, Carl Osborn and William T. Brumbaugh divided the Fruita Mercantile Company in Fruita into three units. George Finnicum, the former town marshal, ran the grocery and meats store in the Mercantile's original location; Osborn ran the hardware and implements store in the second block of East Aspen Avenue; and Brumbaugh ran the domestic goods store on East Aspen Avenue around the corner from the Mercantile's original location (above). Brumbaugh's brother David ran the Mercantile's branch in Loma. Like many stores at the time, the Fruita Mercantile issued its customers scrip that could be used like in-store money (below). The benefit for customers was the ability to save the scrip and use it when cash was scarce; the benefit for the store was the guarantee of return customers since the scrip could not be used elsewhere.

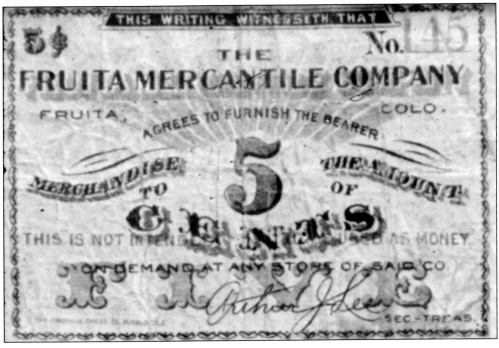

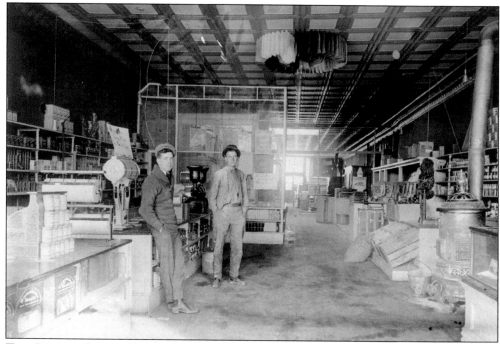

Two Grocery Stores. During World War I, the Brumbaughs disposed of their businesses and moved to Oklahoma for a couple of years. During the brothers' absence, the space housed first the Fruita Grocery Store, pictured above, operated by Grover (left) and George (right) Fuller, and then the Fruita Dry Goods Company. William and David Brumbaugh returned to Fruita in 1920, bought out Finnicum's grocery, and opened Brumbaugh Brothers Grocery (below) in the same location the Fruita Mercantile domestic store had been. Meanwhile, around 1917, Carl Osborn moved the hardware and implements unit from its location on East Aspen Avenue back to North Park Square, taking up the building immediately north of the First National Bank.

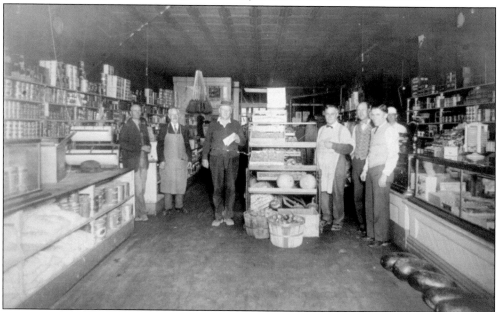

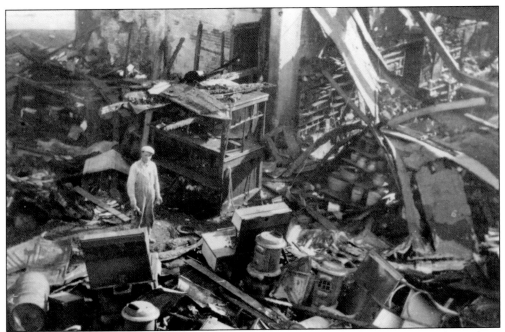

A Devastating Fire. Osborn's Hardware, which faced west, was connected at a right angle to the Brumbaughs' grocery, which faced south, at the rear of both stores, behind the First National Bank building. Early in the morning of December 9, 1929, the hardware store and the grocery, both heavily stocked for Christmas, were destroyed by fire.

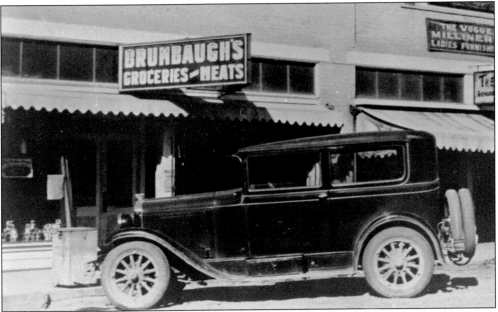

The Brumbaughs' New Grocery Store. After the fire, neither Osborn nor the Brumbaugh brothers gave up, and both stores soon reopened elsewhere. The Brumbaughs set up their new store one block farther east on the north side of East Aspen Avenue, and despite the incredible financial loss caused by the fire, compounded by the encroaching Depression, they stayed in business until they retired in 1942.

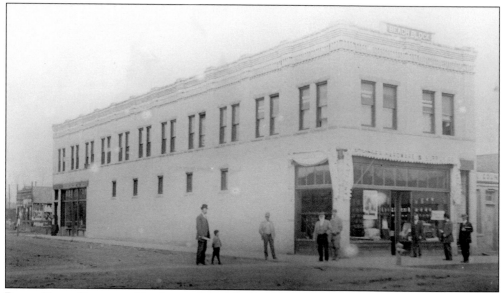

BEACH BLOCK BUILDING. Needing a meeting hall, the Fruita Hesperia Masonic Lodge purchased lots on the northeast corner of East Aspen Avenue and North Mulberry Street in 1904. A March 1904 article in the *Grand Junction News* states, "it is understood that a commodious lodge hall will be arranged for the upper story and business rooms below, and when completed, will be second to none." The brick building was designed by architect Willus Gullette but not built until 1910. It is unclear why construction was delayed six years or why Calvin R. Beach's name appeared on the building, but Beach was a charter member of the lodge as well as a prominent businessman. Both the top photograph taken by Pearl Roach in 1911 and the bottom photograph taken by Minnie Hiatt in 1913 depict Bolinger Hardware and Supply.

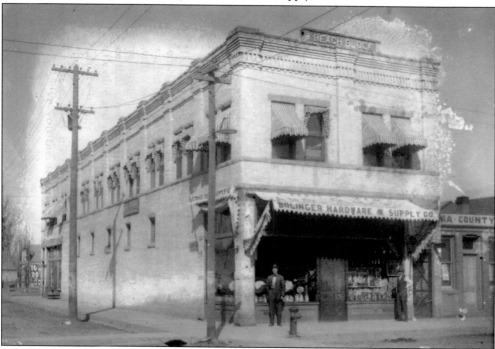

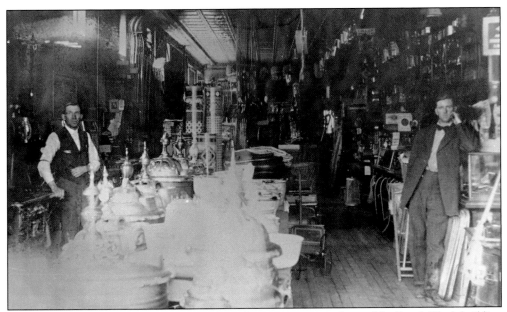

BEACH BLOCK BUSINESS INTERIOR. A number of businesses operated out of the Beach Block building in its early years, including the first downstairs tenant, Bolinger Hardware and Supply, owned by Oscar J. Bolinger, the interior of which is seen in this photograph. Albert B. Timmerman's Furniture and Undertaking was located here for several years after Bolinger's moved out. Timmerman's had earlier been located for some time directly across the street.

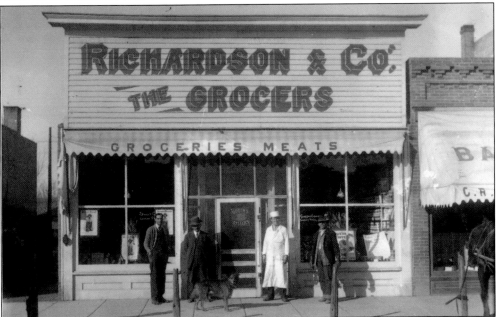

RICHARDSON GROCERS IN 1913. Arthur R. Richardson's grocery was located on the north side of East Aspen Avenue, east of the Beach Block. Richardson had earlier partnered with Otto Shide, and they called their shop Shide and Richardson—The Grocers. They advertised carrying Chase and Sanborn's tea and coffee. After 1911, the store was called Richardson and Company—The Grocers. To the right is Calvin R. Beach's bakery.

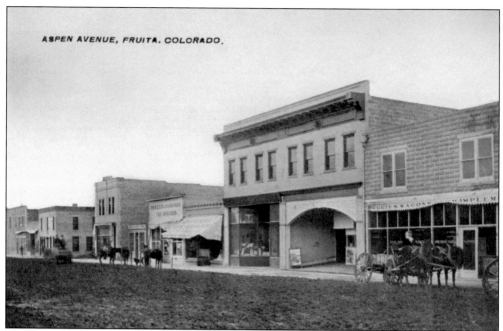

EARLY ASPEN AVENUE. This postcard from about 1911 depicts the north side of East Aspen Avenue, looking west. The buildings are, from left to right, the soon-to-be First National Bank, Fruita Mercantile dry goods, Dr. Charles Masser's building, the Beach Block (containing Bolinger Hardware), *Mesa County Mail*, Shide and Richardson Grocers, Calvin R. Beach Dry Goods, Loeffler's Clothing, Majestic Theater, and Fruita Mercantile farm and implement. (Authors' collection.)

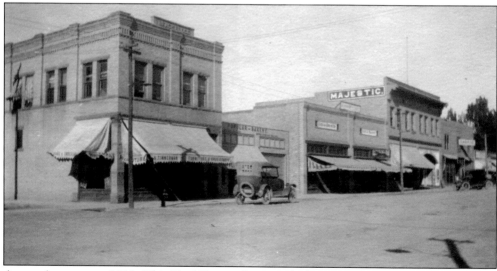

ASPEN AVENUE, C. 1918. This Fred Fraser photograph depicts several changes from above. Timmerman's Furniture and Undertaking has moved into the Beach Block. The three buildings containing the *Mesa County Mail*, Richardson's Grocery, and Beach's store have been demolished and replaced with two buildings housing Evans and Son's Popular Bakery and Cox and Brewer's Grocery. Loeffler's Clothing is gone, and the Fruita Garage has replaced the Fruita Mercantile farm store.

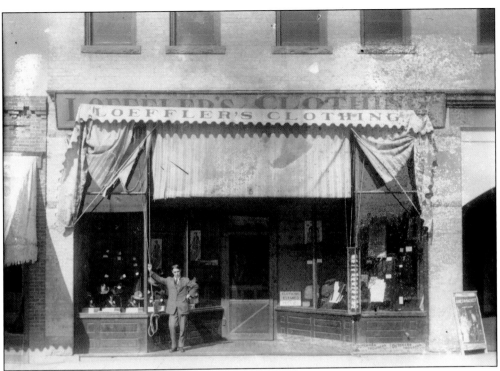

LOEFFLER'S CLOTHING STORE, 1913. Worris H. Loeffler, a native of Austria, sold men's clothing and furnishings for three or four years from this retail shop space in the west side of the Majestic Theater building. Signs in his windows advertise Thoroughbred Hats, Dutchess Trousers, and Spirit Garments. Loeffler's also cleaned and pressed clothing. The movie sandwich board adjacent advertised *The Prisoner of Zenda*, starring James K. Hackett, released in 1913.

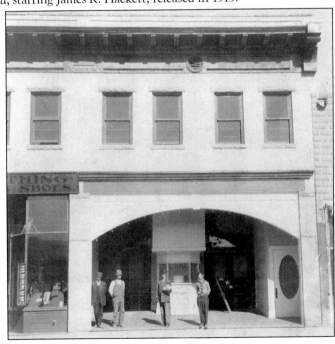

MAJESTIC THEATER, 1911. The Majestic Theater was opened as a movie house in 1910 by Michael Kiefer. Its next owners were Samuel and Lottie Sturtevant, who later sold it to Fred and Carrie Fraser, who eventually renamed it the Rialto. Robert and Melba Walker later bought it and ran it as the Uintah. The theater closed in the 1960s and the *Fruita Times* currently operates out of the building.

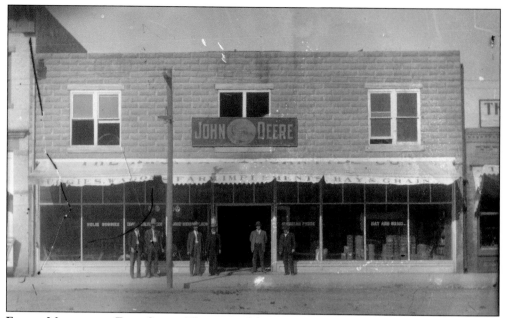

FRUITA MERCANTILE FARM STORE. This unit of the Fruita Mercantile Company, located on the north side of East Aspen Avenue in 1913, was the feed, seed, and farm implement store and was a licensed dealer of John Deere products. This was the branch Carl Osborn ran after the Mercantile's division around 1911. The building is made of formed concrete blocks.

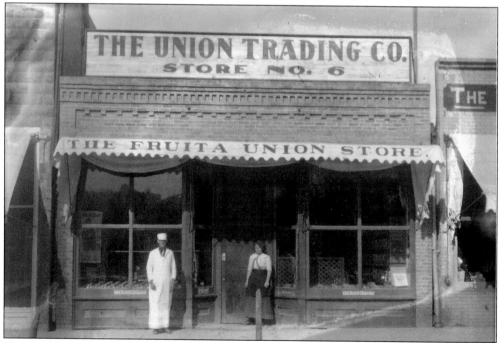

UNION TRADING COMPANY IN 1913. The Union Trading Company Store No. 6 was located on the north side of East Aspen Avenue next to the Cash Hardware and Grocery Store. At the time this photograph was taken in 1913, this store was operated by Joseph P. Talley and his wife, Rosanna; within a few years, it was being run by L. Edward Gredell and his wife, Lydia.

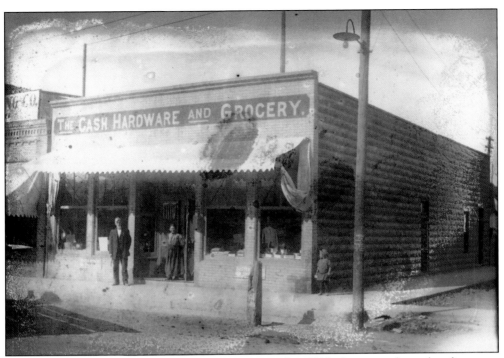

THE CASH HARDWARE AND GROCERY STORE. Pictured in 1913, this general merchandise store, for many years owned and operated by Charles H. Barnes, a former blacksmith from New York, and his second wife, Margaret, was located on the northwest corner of East Aspen Avenue and North Peach Street. The store carried everything from canned goods to shoes.

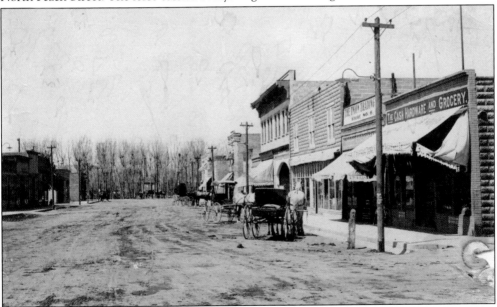

EAST ASPEN AVENUE IN WINTER 1912. This image taken by Pearl Roach from the middle of the street at the intersection of East Aspen Avenue and Peach Street shows the north side of Aspen Avenue looking westward toward Bronk Park. The bandstand is visible through the thicket of denuded trees.

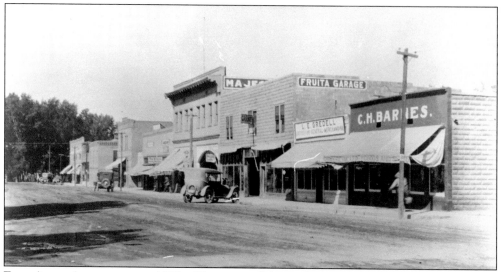

EAST ASPEN AVENUE IN THE 1920S. The name of the Cash Hardware and Grocery had by this time been changed to C. H. Barnes, after the owner, Charles Barnes. Next door, L. Edward Gredell changed the name of his Union Trading Company store to L. E. Gredell. Farther down the street is the Vogue, a ladies' dress shop operated by Pearl Roach until the 1940s.

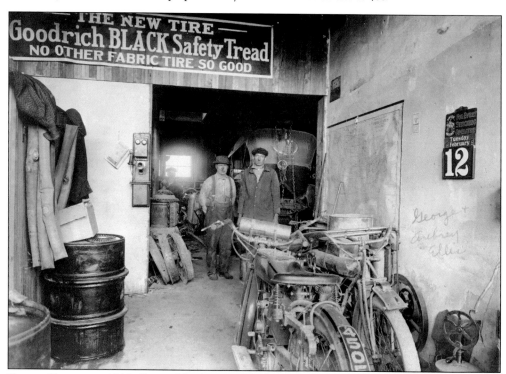

FRUITA GARAGE IN 1918. George Newbury and Aubrey Ellis ran the Fruita Garage on East Aspen Avenue in the building just vacated by the Fruita Mercantile farm store. Newbury had built many items for Dr. James Beard and had run a repair shop with Beard's son John Beard. Ellis was chief of the Fruita Volunteer Fire Department from September 1921 to January 1924. The motorcycles in the foreground are Indians.

DR. HURST'S OFFICE. In 1913, when this photograph was taken by Minnie Hiatt, this building at 332 East Aspen Avenue was the medical office and residence of Dr. A. L. Hurst. Dr. Hurst apparently did not stay in Fruita very long. Today the same building, which was built in the Free Classic Queen Anne style, serves as a funeral home.

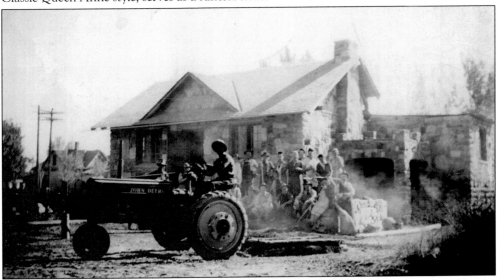

ROCKADAY HOUSE. The Fruita Museum was constructed in 1938 by workers employed by the Works Progress Administration, a Roosevelt administration program. The building was designed as a museum, but for many years it served as the Fruita Library. It currently houses the Fruita Chamber of Commerce. It is constructed of a variety of stones, mostly from near the Colorado River, but also including stones and fossils from locations worldwide.

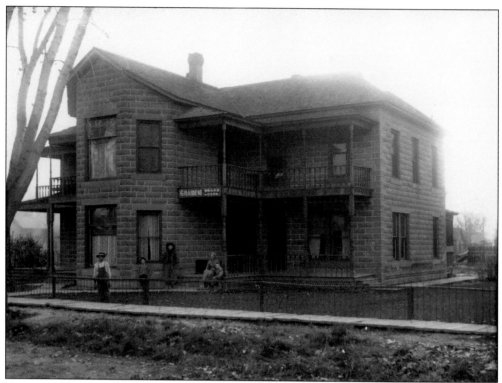

GRAIDENE HOSPITAL. This concrete block building located on South Elm Street about half a block south of East Aspen Avenue was originally built by Fred Ripley and was run as a boardinghouse for teachers called the Graidene Hotel (above). The building was purchased by Dr. James S. Orr and converted into the Fruita Community Hospital in 1922 (below). The hospital operated for many years until a larger hospital was built in 1952. The building is now a private residence and still has the Graidene plaque above the second-story window. The top photograph was taken in 1913 by Minnie Hiatt, the bottom about a decade later.

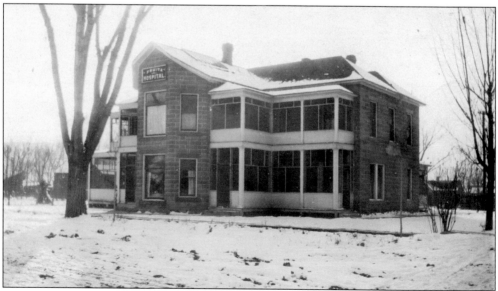

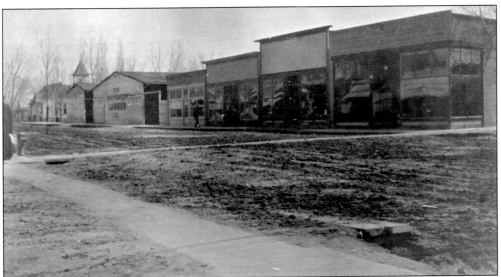

South Side of Aspen Avenue. This photograph was taken by Pearl Roach on April 11, 1911. From left to right sits the Fruita Congregational Church, Independent Lumber, a hardware store probably connected with Independent Lumber, a bakery (probably Olaf's Bakery), a pool room, and the Fruita Furniture Store. The building at the far right is the only one of these to have survived into the 21st century.

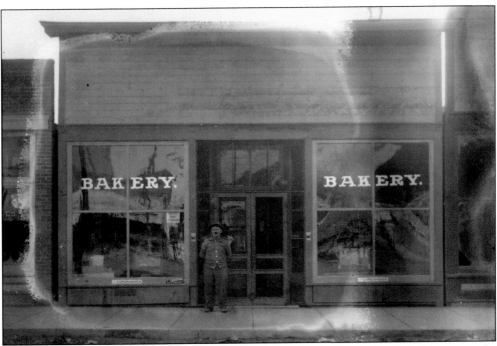

Bakery in 1913. There were many bakeries in Fruita over the years, including this one on the south side of East Aspen Avenue, between Mulberry and Peach Streets, next to the pool hall, pictured in 1913. This is probably the bakery of J. Olaf Burns, the brother of Minnie Hiatt, the woman who took the 1913 business and home photographs. In addition to baked goods, this bakery also sold tobacco.

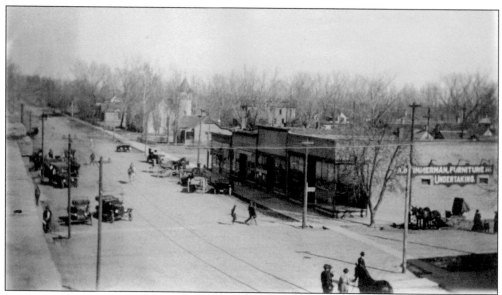

SOUTH SIDE OF ASPEN AVENUE FROM ABOVE. Fred Fraser took this rooftop view of East Aspen Avenue in 1912 or later. Independent Lumber is gone. Albert B. Timmerman's Furniture and Undertaking sits at far right. In the 1910 high school yearbook, an advertisement for Timmerman's advises, "Don't Get Married!—Until you have finished your school; but when you do, buy your home furnishings of [sic] the Timmerman Furniture store."

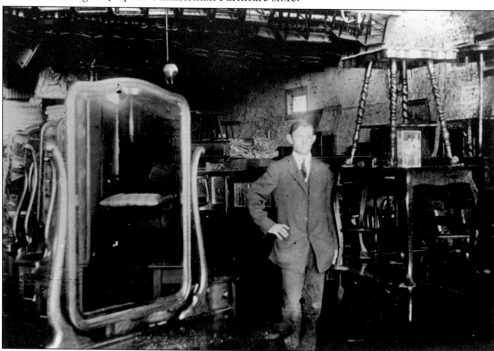

INTERIOR OF FURNITURE STORE. The very crowded interior of Albert B. Timmerman's Furniture and Undertaking was photographed when the store was located on the southeast corner of East Aspen Avenue and South Mulberry Street, before it was moved across the street into the Beach Block where Bolinger Hardware and Supply had previously been.

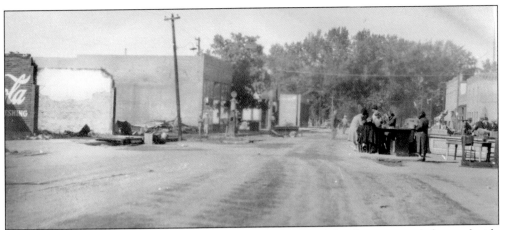

BUSINESS DISASTER OF 1926. On September 24, fire destroyed four businesses on the south side of East Aspen Avenue. The fire likely started at the Thirsk Potato Chip Factory and spread to Michael Fromm's harness shop (a different location from the 1913 photograph), David Bryant's barbershop, and the Hayden Garage. Losses were estimated at $10,000. Townspeople saved most of the stock and furnishings by dragging them into the street.

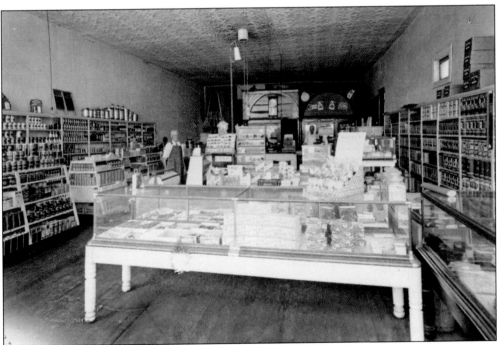

MCELFRESH AND LOCKETT STORE INTERIOR. Harry G. McElfresh and James L. Lockett owned, and Daniel Righdenour managed, the grocery store on the southeast corner of Aspen and Mulberry during the 1930s. The store was located in the building that had previously housed Albert B. Timmerman's Furniture and Undertaking. Righdenour had formerly worked for Carl Osborn in the Fruita Mercantile Company.

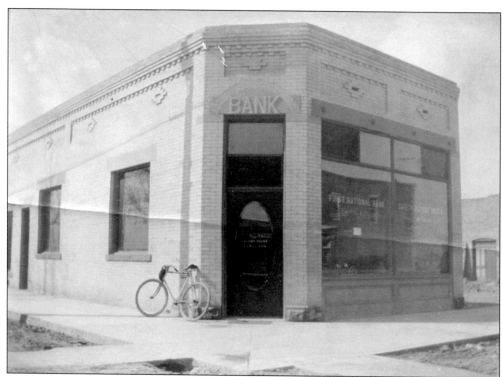

FIRST NATIONAL BANK WITH BICYCLE. This building, which looks much the same today, was built in 1900 for the Farmers and Merchants Bank of Fruita. That bank closed, and the First National Bank of Fruita took over the building in 1906, remaining there until 1912, when it moved across the street into what is today called the Mid-Valley Building. This Pearl Roach photograph was taken in 1911.

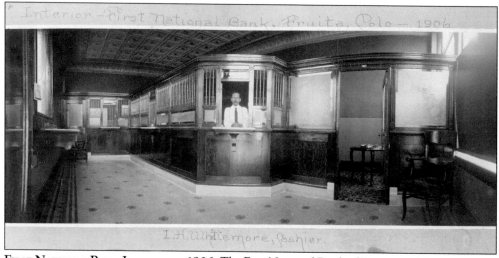

FIRST NATIONAL BANK INTERIOR IN 1906. The First National Bank of Fruita, established in 1906, was first located at the southwest corner of East Aspen Avenue and South Mulberry Street. This photograph showing the bank's 12-foot ceiling of sculptured tin (which remains today), floor of Italian tile, and mahogany teller cage manned by cashier Ira H. Whittemore was taken by Ed St. Clair of the Lone Star Gallery in Fruita.

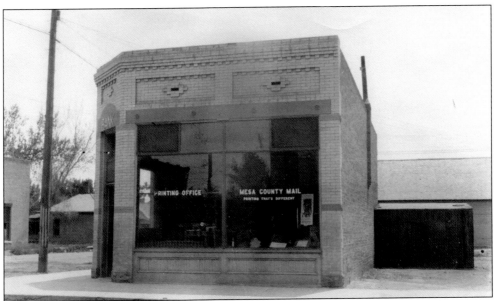

MESA COUNTY MAIL IN 1926. After the bank moved, this building housed a number of businesses, including a barbershop, the *Mesa County Mail*, the *Fruita Times*, and a coffee shop. In addition to the *Mail* and the *Times*, other Fruita newspapers included the *Star*, which William Pabor started in 1889 but stopped after an 1891 fire; the *Record*; the *Telegram* (1906–1909); and the *Independent* (1901–1904).

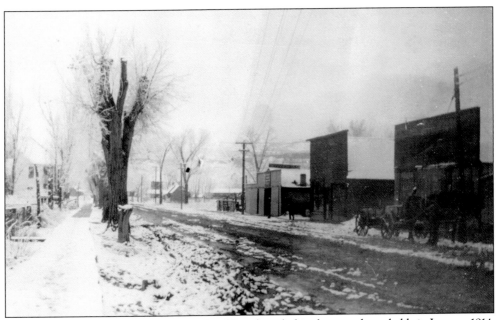

SOUTH MULBERRY STREET IN THE SNOW. Pearl Roach took this photograph, probably in January 1914. The White House Hotel is just visible on the left side of the street. On the right side, the third building from the right is City Dray and Transfer, owned and operated by Roach's husband, William; the second is Roach's Livery and Garage; and the first is the former site of George Nees's blacksmith shop.

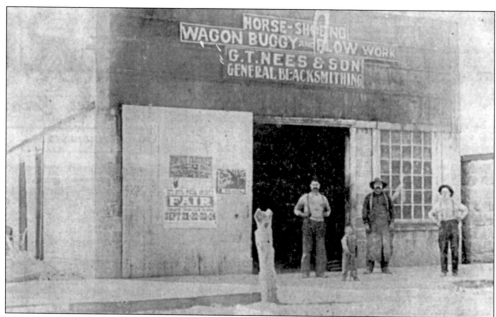

G. T. Nees and Son General Blacksmithing, 1909. George T. Nees and his son, Ira, were the proprietors of this business located about two lots south of the First National Bank on South Mulberry Street. Posters advertise "Bing's Clothes—The label guarantees style, durability and honest value—Sold at Fruita Mercantile, Co., Fruita, Colo."; "5A Horse Blankets—G.E. Barton"; and "Sixth Annual Mesa County Fair, Grand Junction, Colo., Sept. 21-22-23-24."

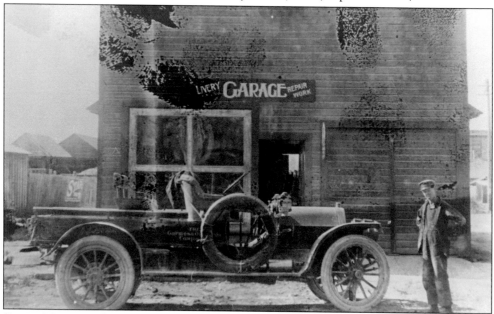

South Mulberry Street Livery and Garage. In addition to the City Dray and Transfer, the ever-busy William Roach also operated the Livery and Garage seen in this 1913 photograph. The man in the photograph, presumably Roach's mechanic, is unidentified. The vehicle parked in front was owned by the Garmesa Orchards Company, a company-owned farm community founded by Quaker Oats in 1911, located about 15 miles north of Fruita.

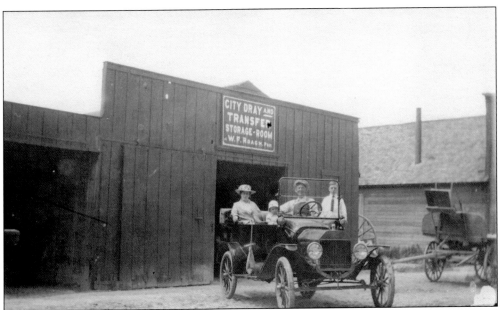

CITY DRAY AND TRANSFER. Located on the west side of South Mulberry Street and owned and operated by William. F. Roach, this company offered moving and storage services, with "heavy hauling a specialty" and "pianos moved with care and dispatch." Posing in the family's 1915 or 1916 Model T Ford are, from left to right, Pearl Roach; the Roaches' adopted son, Bernard; William Roach; and their nephew Donald Roth.

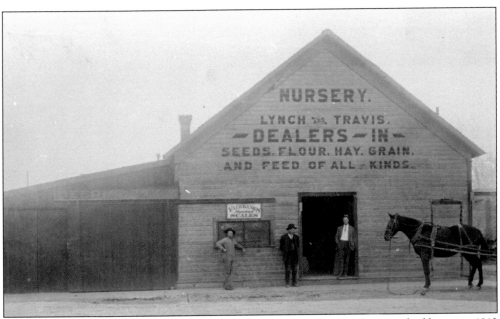

LYNCH AND TRAVIS NURSERY. This nursery and feed and seed store, photographed between 1910 and 1915, was run by Daniel W. Lynch and either Daniel or Lee Travis and is thought to have been located on South Mulberry Street. From left to right, John Austin, Lynch, and Leonard A. Stewart pose in front of the building. The signs advertise Fairbanks Standard Scales and Deering Implements.

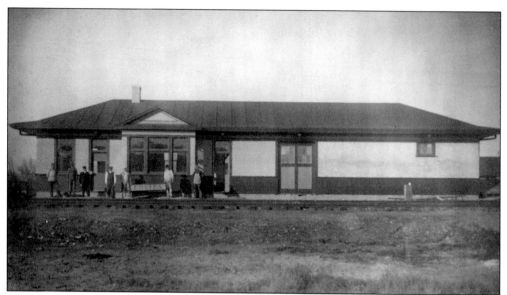

FRUITA RAILROAD DEPOT. From about 1883, a narrow gauge track ran through Fruita on its way between Grand Junction and Salt Lake City. The Denver and Rio Grande Railroad improved the line to a standard gauge and built a depot at Fruita in 1889. This was extensively remodeled in 1911, as seen in this photograph by Pearl Roach, with more room for freight and baggage.

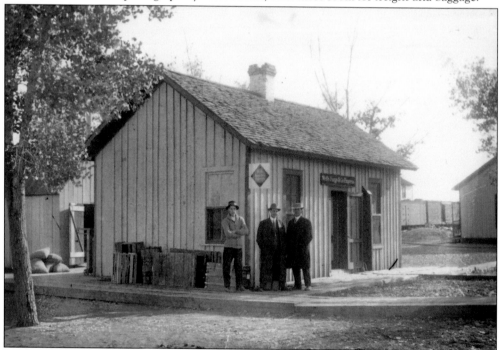

WELLS FARGO AND COMPANY EXPRESS. Wells Fargo and Company was founded in 1852 by Henry Wells and William G. Fargo as an express delivery service. The company quickly branched into banking, rail freight, stagecoaches, mail delivery, payroll security, and more. In 1905, the banking and express divisions separated; the express division closed altogether in 1918. This 1913 photograph shows the Fruita express office near the railroad tracks.

THE FRUITA BRIDGE. Besides requiring irrigation water for agriculture, Fruita residents needed fresh water for drinking and cooking. In 1907, Fruita built a bridge over the Grand (Colorado) River to accommodate a water pipeline from spring-fed reservoirs high above the town on Piñon Mesa. The wooden pipeline ran 23 miles between the reservoirs and Fruita, following an old rock-cut cattle road known appropriately as the Fruita Dugway (which was widened for the project with dynamite). Because the bridge would improve traffic over the river, the state and county contributed funds towards its construction, but Fruita had to cover the $130,000 water project cost alone. Fruita issued bonds to raise capital but had to first enlarge by annexation because state law set municipal bond issuance limits to the town's real estate valuation. (Right, Authors' collection.)

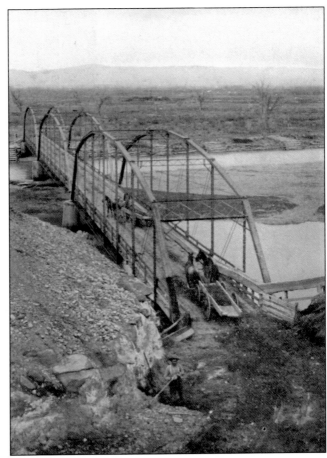

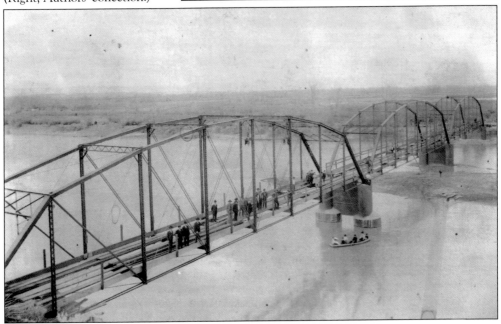

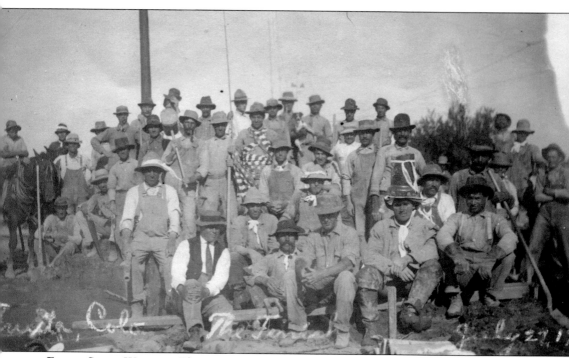

FRUITA SEWER WORKERS. The year 1911 was important in Fruita's history. Town founder William Pabor died in September and was buried in Fruita. Electricity had been introduced the year before with the arrival of the Interurban, and now electrical lines were starting to slowly work their way toward downtown. The Colorado National Monument was established. And although no one knew it yet, fruit production would start its decline that year with a crop-destroying hail and culminate a decade later with the forced destruction of orchards to eliminate the coddling moth. This Pearl Roach photograph titled "The Finish" commemorates another important (if unsung) day in Fruita's story: The community could not continue to grow without fresh water piped to each home and business and without a viable sewage and drainage system. These hard-working men are shown at the completion of their several-years-long task of installing sewage and drainage pipes in Fruita. The men proudly display some of their tools, and one is celebrating the event by wearing a piece of ceramic sewer pipe on his head. (Courtesy of Bobbi June Fisher.)

Five

CHURCH, SCHOOL, AND HOME

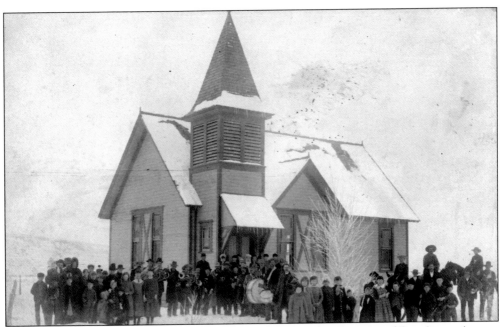

UNION CONGREGATIONAL CHURCH. Frame-built on the southeast corner of East Aspen Avenue and South Peach Street, Fruita's first church was dedicated in December 1889. A yellowed note lists the celebrants as, "Three school teachers, Miss Minnie Ritchie later Mrs. W. H. [William] Violett, Miss Mabel E. Steele later Mrs. F.D. [Frank] Kiefer, Professor Edward T. Fisher, and Pastor the Reverend Beers, school children, and the first band . . . and [a] few old timers."

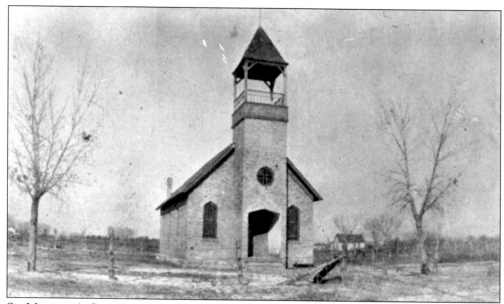

ST. MALACHY'S CATHOLIC CHURCH. Located in Cleveland, a community bordering and slightly southeast of Fruita that was annexed into Fruita in 1905, this church was built in 1890 on land donated by the Kiefer family. It served as the primary place of worship for Catholics in the vicinity until the present Sacred Heart Church was constructed in Fruita in 1922. St. Malachy's rectory was moved to Fruita at that time.

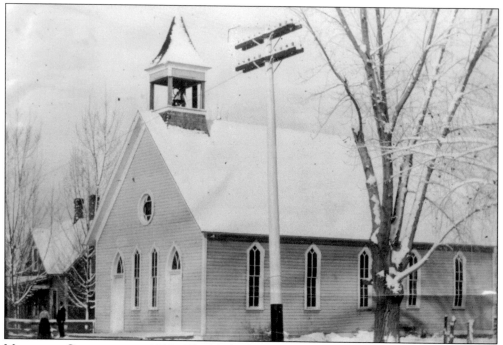

METHODIST CHURCH IN THE 1890s. The Methodist Episcopal Church was organized in November 1884. The first church, a frame structure, was built in 1893 on the corner of East Aspen Avenue and South Maple Street. The parsonage sits to the left. In 1908, a new, larger church was built of brick at the corner of East Aspen Avenue and North Elm Street. That church is still used today.

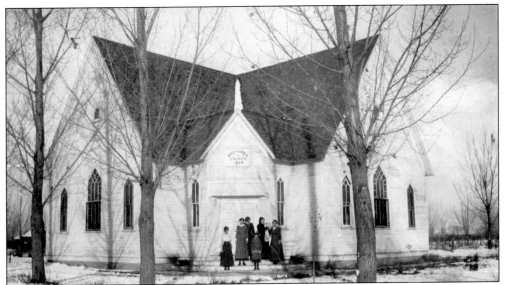

FRUITA CHURCH OF THE BRETHREN. The Brethren Church, located on the northeast corner of Maple Street and Pabor Avenue, was built in 1904 for a cost of $1,720, exclusive of labor. Several Fruita businesses, including the Bolinger and Merriell Lumber Yard in Fruita, furnished material for the construction, and many Fruita residents donated their time and helped with the labor. The church was originally painted white and has remained white ever since.

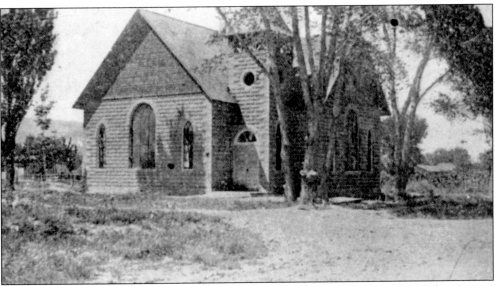

FIRST BAPTIST CHURCH. This church was located on the southwest corner of East Pabor Avenue and North Elm Street. The building is constructed of concrete blocks made by the congregation, who built the church in 1907. The building has been remodeled over the years and is currently in use as a private residence.

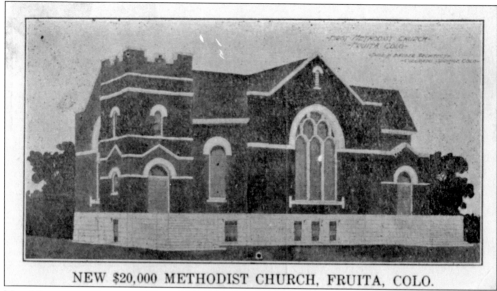

NEW $20,000 METHODIST CHURCH, FRUITA, COLO.

NEW METHODIST CHURCH. When the Methodist congregation outgrew their original church, it was replaced in 1908 with the present brick building, shown in this postcard, located at the northwest corner of Aspen Avenue and Elm Street. The church was designed by Thomas Barber, an architect from Colorado Springs, and the construction cost was $20,000. (Authors' collection.)

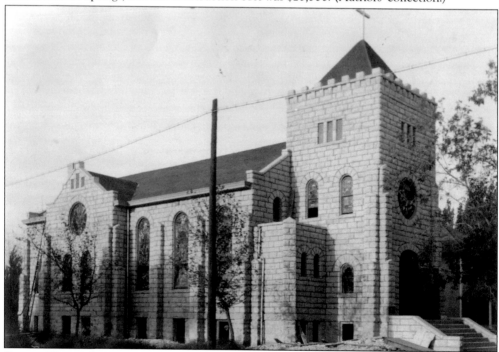

SACRED HEART CATHOLIC CHURCH. The Catholic church was constructed in 1922 from native sandstone for a cost of about $16,000. The church is located on the northeast corner of East Aspen Avenue and North Maple Street. The dedication ceremony was held August 22, 1922, and was conducted by the bishop of Denver, the Rt. Rev. J. Henry Tihen. This photograph was taken shortly before construction was completed.

84

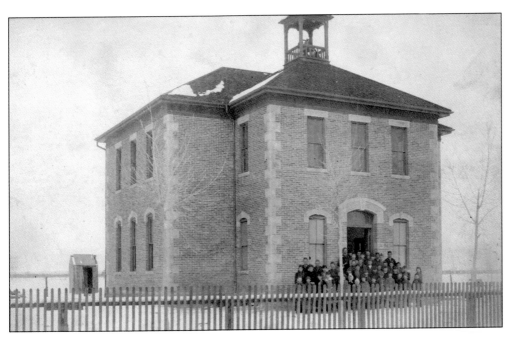

CENTRAL SCHOOL. This red brick building was built in 1887 on the southwest corner of the East Aspen Avenue block between North Elm and North Peach Streets. Grade school classes were taught downstairs, and from 1890 until 1904, three-year high school classes were taught upstairs. A rear addition was built in 1894, which is when it became known as Central School. The addition was replaced in 1912 by the New Central School built farther northeast on the same grounds, and the original building was torn down in 1935 when additions were added to the newer building. Both photographs capture the 1887–1888 students and teachers posing in front of the school. The principal was Edward Fisher and the teachers were Anne Barrett and Mabel Steele. Fruita was Mesa County's second school district, after Grand Junction, hence the "02" over the door.

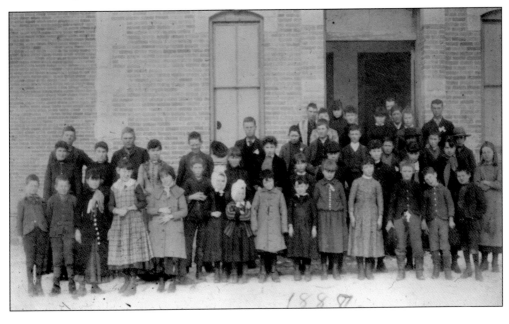

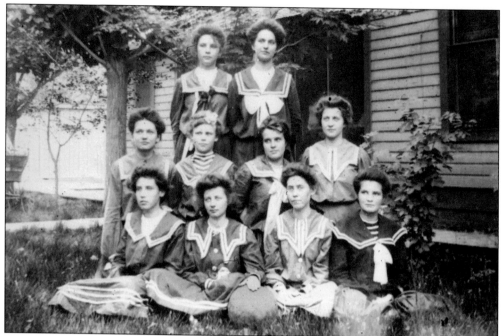

GIRLS' BASKETBALL TEAM. In the top photograph, the 1904 or 1905 Fruita high school girls' basketball team poses in their homemade uniforms. The only identified girl in the photograph is Margaret Cox, who is standing in the rear row to the right, although at least one of the girls, and perhaps more, appears in the HGL Club photograph on page 89. In the bottom photograph, girls are shown playing basketball in 1902 or 1903. There was no gymnasium in Central School where Fruita's high school classes were still being held, so the girls played on an outdoor court, cheered on by large crowds of spectators. The below-the-knee dresses and stockings they wore were undoubtedly quite warm and cumbersome for playing in.

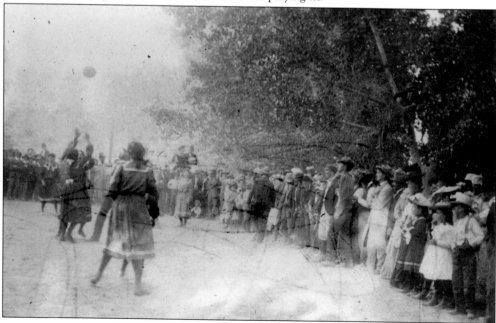

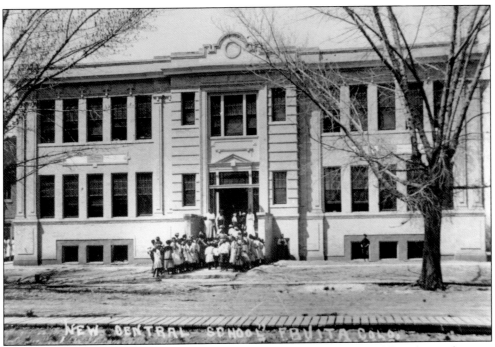

NEW CENTRAL SCHOOL. The New Central School was built in 1912 at 325 East Aspen Avenue. Additions were constructed in 1935 by the Works Progress Administration. The school served students in grades one through eight. Shortly after reorganization into Mesa County Valley School District 51 in 1951, the name was changed to Fruita Elementary School. After Shelledy Elementary School was completed in 1959, grades one and two were sent there. The last school year classes were held in the school was 1981–1982. The school was remodeled in the 1980s and is now used as the Fruita Civic Center. The photograph of the teachers was taken shortly after the building was completed.

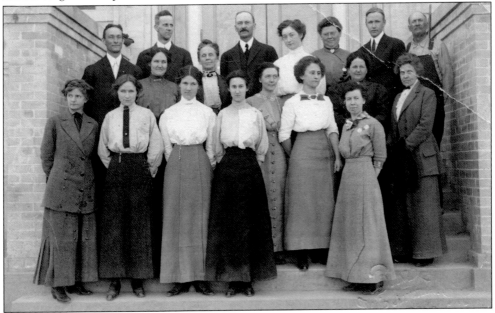

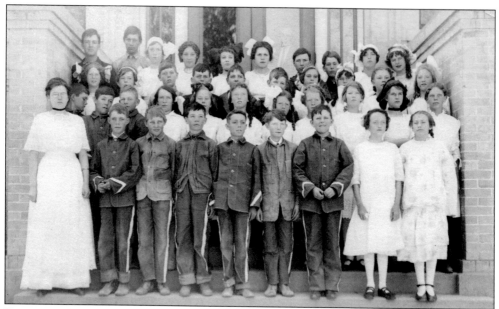

FIFTH AND SIXTH GRADE CLASSES. These two class photographs of students at New Central School were taken several years apart. The top photograph was taken within two or three years of the school's 1912 opening, and the bottom photograph was taken in October 1921. During those years, the style of dress changed a great deal. In the earlier photograph, the students are dressed more formally, with the girls wearing Mary Pickford–style curls and bows and the boys wearing homemade band uniforms. Many of the students in the area came from farm and ranching families, and in 1921, this is borne out by the denim overalls worn by most of the boys. Three of the boys also sport neckties with their overalls.

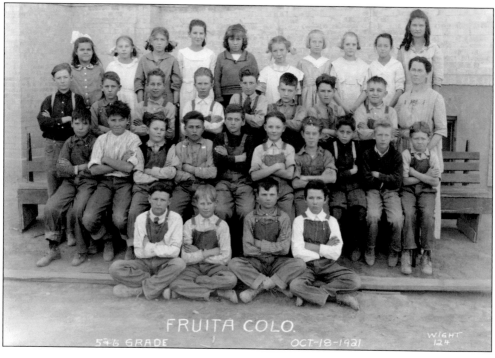

FRUITA UNION HIGH SCHOOL'S FOUNDING. There were several school districts in the Lower Valley, but none of them had a dedicated high school. Classes were instead held in the grade schools. These districts included Fruita, Loma, Rhone, and Star. In 1904, these districts combined to form a union high school. The districts of Hunter, New Liberty, and Mack joined the union a few years later. (Authors' collection.)

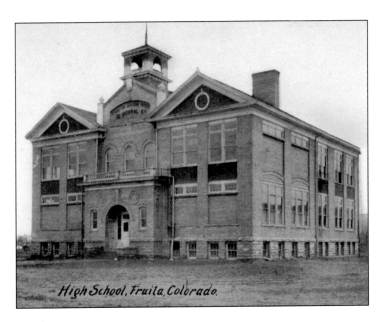

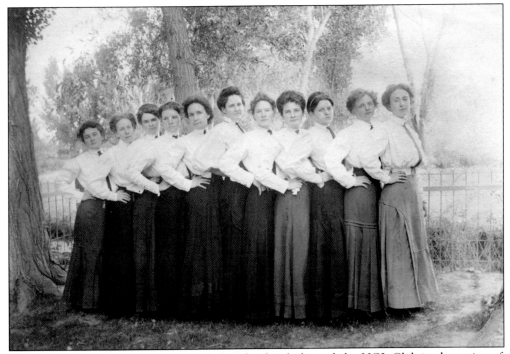

HGL CLUB. A dozen Fruita Union High School girls formed the HGL Club in the spring of 1906, and its members maintained lifelong friendships, even holding a reunion in 1952 at Grand Junction's LaCourt Hotel. The meaning of "HGL" was known only to the club's members, but it may have stood for "Happy Go Lucky." These 11 of the 12 members of the club were photographed by Pearl Roach.

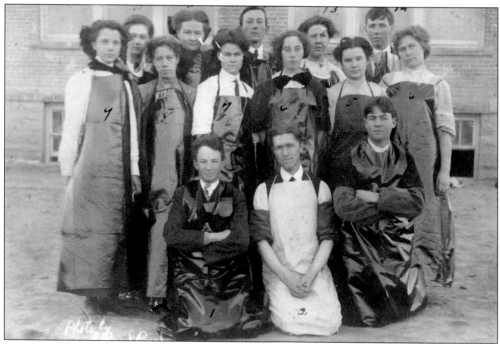

CHEMISTRY STUDENTS. The 1912 class motto was, "We build the ladder by which we rise." The chemistry class stopped building only long enough to pose for Pearl Roach. Pictured from left to right are (first row) Harry Brown, Prof. Alfred Hampton, and Dorr Finnicum; (second row) Viola Burson, Inna Svanson, Faye Botkin, Katie Vaughn, Nina Turner, and Ruth Mainard; (third row) Belle Paige, Florence McKinney, Harold Heill, Agnes Ashford, and Frank Moore.

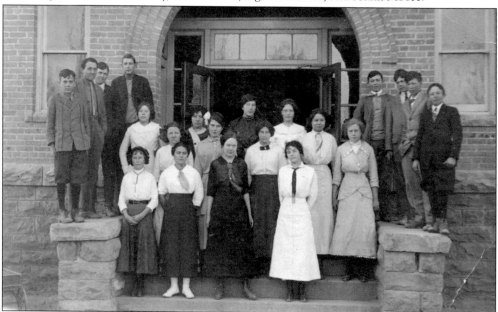

HIGH SCHOOL STUDENTS IN 1914. This group of students posed on the front steps of the high school. There were six members on the faculty that year, including Supt. L. B. Stevens, who had been a school principal in Leadville, and principal Minnie Hall.

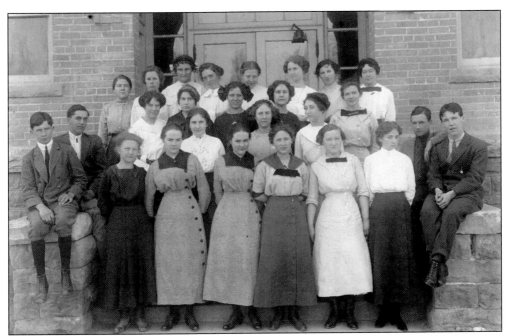

SENIOR CLASS PHOTOGRAPH. The Fruita Union High School class of 1914 poses for their class photograph on the front steps of the school. There were 21 graduates in 1914. The class motto for that year was "Labor Opens the Gates," and the class flower was the yellow rose. The class president was Ruth Kirkendall and the valedictorian that year was Elsie Lowenhagen.

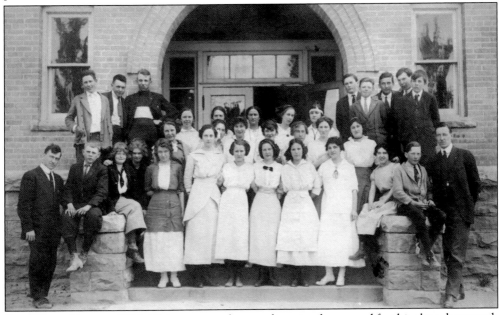

SOPHOMORE CLASS IN 1915. Thirty-one students and two teachers posed for this class photograph on the steps of the high school. Most of the girls wore matching white dresses. While most of the boys dressed in jackets and ties, one in the back on the left has worn a football-type sweater under his jacket instead. When these students graduated in 1917, there were only 24 students in their class.

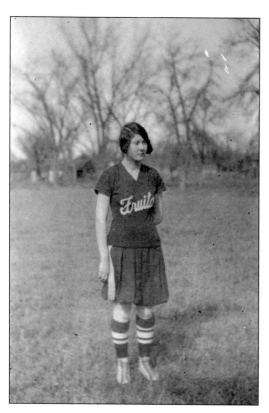

ROSELTHA BEARD IN BASKETBALL UNIFORM. As can be seen from this photograph, by 1928 the girls' sports uniforms had changed greatly from those from around 1903 (shown on page 86) when the team members wore loose blouses and skirts that fell below their knees. The new uniform was made entirely of wool, the top a short-sleeved knit sweater. Roseltha was named after her paternal grandmother, Dr. James Beard's first wife.

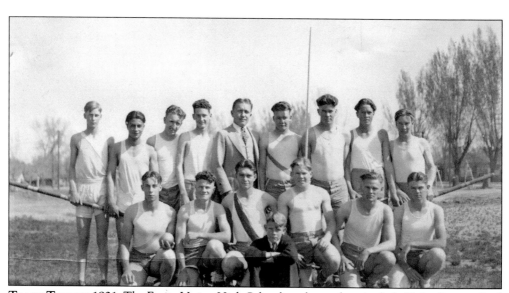

TRACK TEAM IN 1931. The Fruita Union High School track members included John Rogers, Paul Watkins, Earle Wagaman, Larimer Faris, Harley Beeson, Billy Strawn, Bennie Pacheco, Robert Murley, Blaine Standifird, Leo Markrud, Eldon Levi, Clyde Nelson, and Robert Jordan. Coach George Penner stands at center rear.

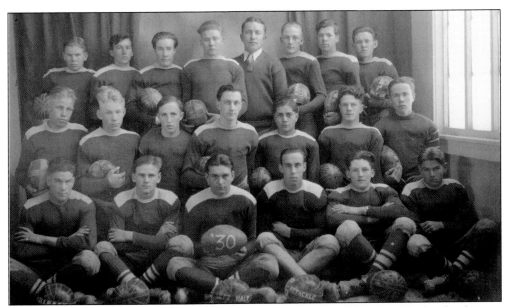

WILDCATS SPORTS TEAMS. Fruita residents were big supporters of their local high school sports teams. These photographs show the Fruita Union Wildcats 1930 football team (above) and the 1931 Wildcats basketball team (below). Football team members included Eldon Levi, Harley Beeson, Earl Wagaman, Forrest March, Harold Moore, Ted Lowenhagen, Porter Mogenson, Douglas Gorman, William Osborn, Frank Peep, Paul Watkins, James Brenneman, Larimer Faris, Glen Austin, Robert Jordan, Leo Markrud, Wilson Weckel, Ralph Arbuckle, and Howard Mayne. Boys' basketball team members included Paul Watkins, John Rogers, Earl Wagaman, Eldon Levi, Robert Jordan, Harley Beeson, Wilson Weckel, Leo Markrud, Robert Murley, Blaine Standifird, and Larimer Faris. Coach George Penner stands at center rear in both photographs.

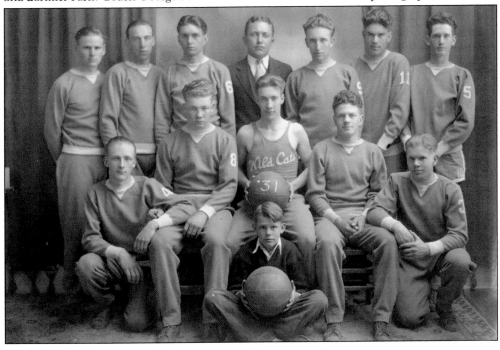

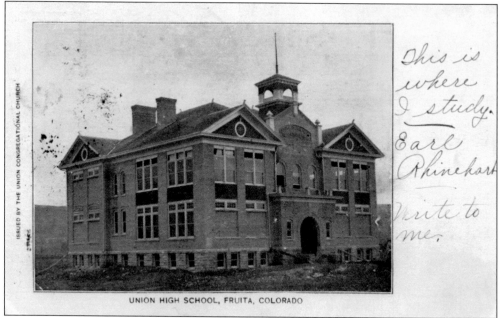

This is where I study. Earl Rhinehart. Write to me.

UNION HIGH SCHOOL, FRUITA, COLORADO

BEFORE THE END. The two-story Union High School was erected in 1904 on a site at South Maple Street and East McCune Avenue purchased from George Reed for $800. This is the site of the current Reed Park. Fruita high school students adopted the wildcat as their mascot and blue and white as their school colors in 1927 and have used them ever since. (Authors' collection.)

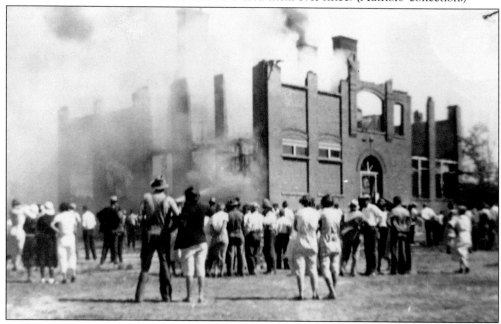

Union High School Fire. The school burned down September 24, 1934. According to the *Fruita Times*, "students had just entered their second hour classes when the fire whistle blew, and at the command of the teachers, left the building in an orderly manner, thinking that it was only a fire drill. It wasn't until most of the students had gotten outside that they realize [*sic*] that the school was really afire."

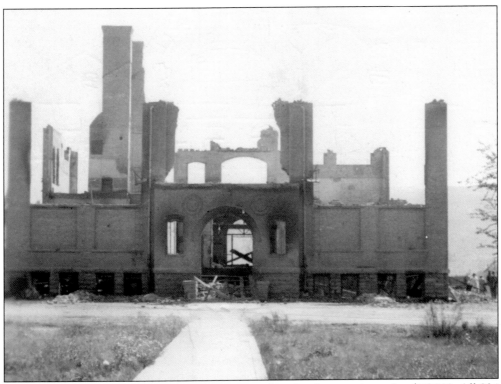

FRUITA UNION HIGH SCHOOL RUINS. Damage to the school was estimated at $45,000. All 234 students and their teachers escaped unharmed. About $500 of new text books just purchased for that school year were also destroyed, as were approximately 1000 jars of canned fruits and vegetables that the students had been collecting for needy residents. The *Fruita Times* stated, "It is thought that the origin of this fire was started by either faulty electric wiring or by sparks from a passing D.& R.G.W. [Durango and Rio Grande Western Railroad] engine." The local water shortage and a strong wind spread the blaze quickly throughout the building and threatened nearby houses. The top photograph depicts the front of the school building a few days after the blaze, while the bottom one depicts the rear of the school.

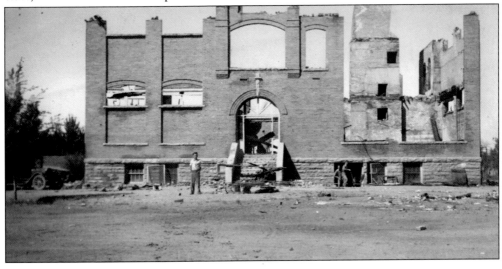

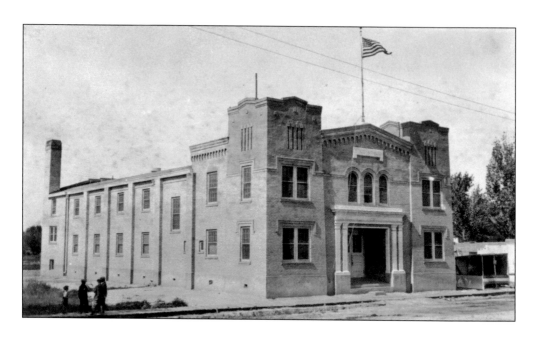

FRUITA ARMORY BUILDING. After the fire destroyed Fruita Union High School in 1934, students were taught in the Fruita Armory building for two years until a new high school could be completed. The armory was built in 1921, and the dedication ceremony was held Sunday, October 29, 1922. One of the speakers at the dedication was Sen. Horace T. DeLong, and rifle and bayonet exercises were held by Company B, 157th Infantry, Colorado National Guard, directed by Sgt. Ed Pattinson. The armory was located on South Mesa Street and was designed by architect John James Huddart, who designed a number of armory buildings in Colorado. In later years, it served as the Fruita City Hall. It was demolished in 1980.

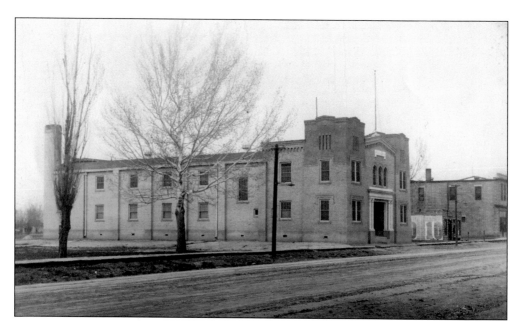

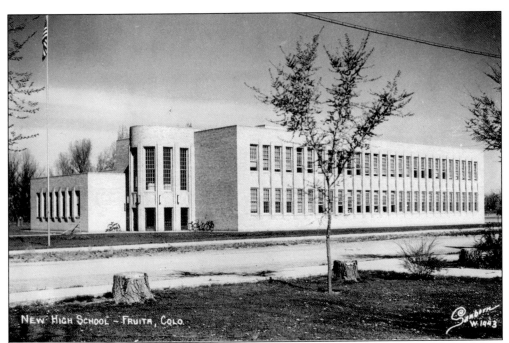

NEW HIGH SCHOOL - FRUITA, COLO.

NEW FRUITA UNION HIGH SCHOOL.
These photographs of the new high school, located on North Maple Street, were taken shortly after its completion. The school was dedicated on October 3, 1936. The school, designed by the firm T. H. Buell, Architects, was featured in the February 1938 edition of *Architectural Forum* magazine for its modern design. (Temple Hoyne Buell is probably most famous for his design of the Cherry Creek Shopping Center in Denver.) The building served as the high school until 1969, when Fruita Monument High School was built. The building has had several additions added on over the years, and the street is now lined with trees. The school is still in use as Fruita Middle School. (Above, courtesy of Derick Wangaard, Sanborn Limited; right, photograph by Frank Dean, authors' collection.)

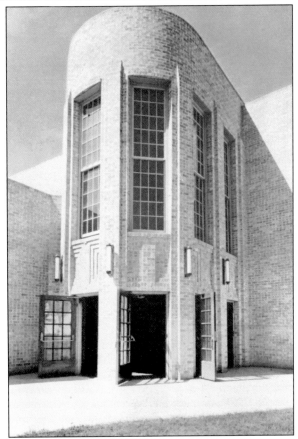

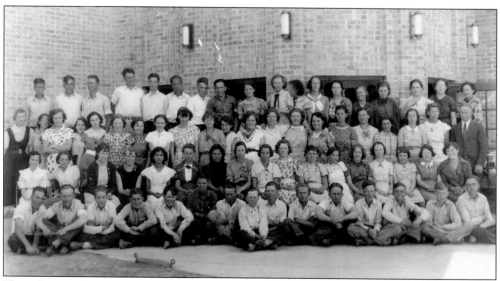

HIGH SCHOOL CLASS PHOTOGRAPH. On May 27, 1937, fifty-four seniors took part in the first commencement exercises. For 33 years, the Wildcats took classes on Maple Street, including these students photographed in the late 1930s. The final class graduated from the new Fruita Union High School in May 1969. A new, much larger high school, Fruita Monument High School, opened in September 1969 and is still used today.

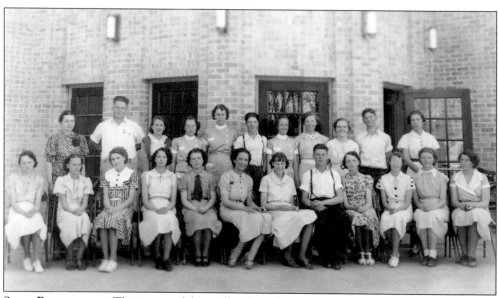

STAFF PHOTOGRAPH. This image of the staff and teachers at the new Fruita Union High School was taken in the late 1930s. Harry A. Williams was the school superintendent, presiding over the move to the new school. The students of the first class to graduate from the new school dedicated the 1937 yearbook to him for "his efforts and diligent labor in the making of our modern high school building."

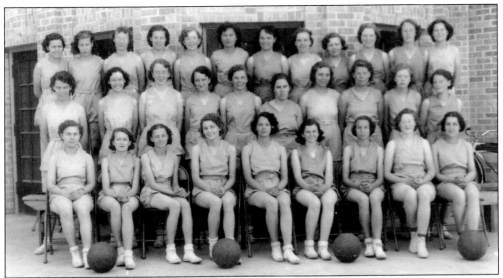

GIRLS' BASKETBALL TEAM IN 1937. The new high school featured a modern gymnasium and offered many opportunities for athletics. Nellie Elliot coached the girls during the fall of 1936, and in spring 1937, after her resignation, the boys' coach, George Penner, coached the girls for the remainder of the season.

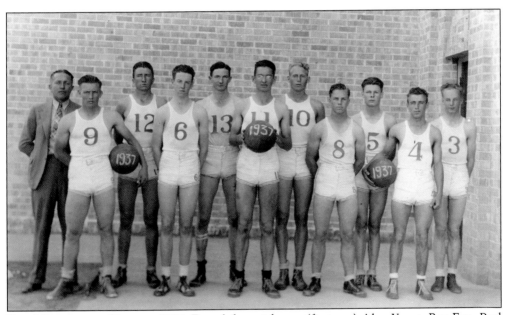

BOYS' BASKETBALL TEAM IN 1937. From left to right are (first row) Alan Yount, Roy Eno, Paul Crockett, Bill Grant, and Glenold Kelly; (second row) coach George Penner, William Keleher, Darrel Maluy, Willard Selke, Raymond White, and Guy Brown. After a season with 12 wins and two defeats, the team made it all the way to the conference semifinals in Delta, where they were defeated by Craig High School.

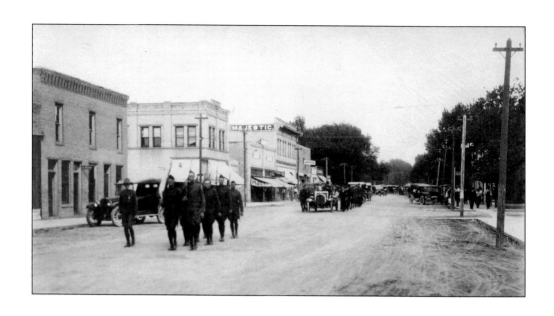

FUNERAL OF HAROLD WAGNER. After graduating from high school, some students go on to college and others go directly to work. Still others are drafted into or sign up for the military. Such was the case for Harold C. Wagner, who served during World War I. Wagner was the son of Hilarian C. Wagner, who had formed Fruita's band and been editor of two of its newspapers, and his wife, Jennie. Harold Wagner was born October 29, 1893, and was killed in France, September 25, 1918, while serving with Company L, 353rd Infantry Battalion, 89th Infantry Division. He was the only Fruita soldier to lose his life in battle during that war. A large, somber military funeral with a procession down Aspen Avenue was held in his honor. (Above, Authors' collection.)

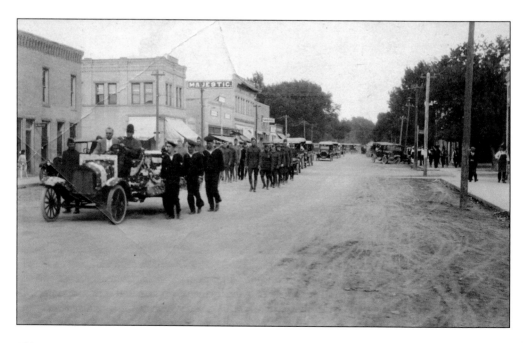

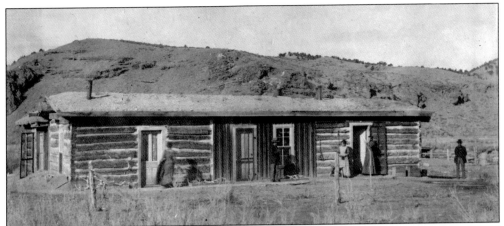

ROTH FAMILY HOMESTEAD. The Roths were among the earliest families to settle in Fruita, and they ran several businesses, including the Pioneer General Store and a millinery. The family later had a home in Fruita, but this early log cabin, photographed December 20, 1890, was not located in the town limits but just south of the Grand River near what is today called Kingsview. (Courtesy of Bobbi June Fisher.)

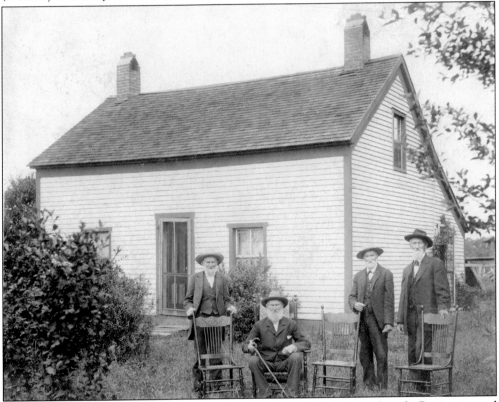

KIEFER BROTHERS. Arriving in 1883, the Kiefer brothers—Valentine, Joseph, Benjamin, and Frank—were among the earliest and most important settlers in the area. They brought irrigation to tens of thousands of acres of farmland, were instrumental in founding Loma, and started a rival town, Cleveland, which was later annexed into Fruita. Frank died in 1909; he is not pictured, but their brother Leopold, who arrived after 1910, is.

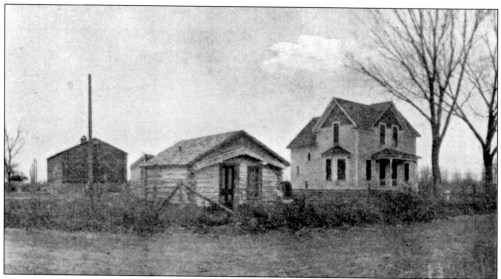

SKINNER RESIDENCE. Located at the northeast corner of West Pabor Avenue and North Coulson Street, the two-story frame home of Darius J. and Nellie Skinner and their large family, built in 1906, is today known as Mulberry Cottage, so called in honor of William Pabor's log cabin, the Mulberries. Pabor's cabin, which no longer exists, can be seen to the left (west) of the Skinner house in the photograph above, approximately where the now much wider North Coulson Street runs today. The Skinner residence was one of the grander early homes in Fruita and was the home of Mabel Skinner, who was elected National Apple Queen in 1910, three years before the photograph below was taken. The Skinner family operated an icehouse on the premises until the 1920s.

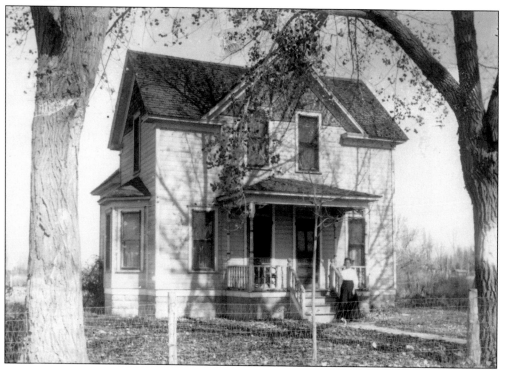

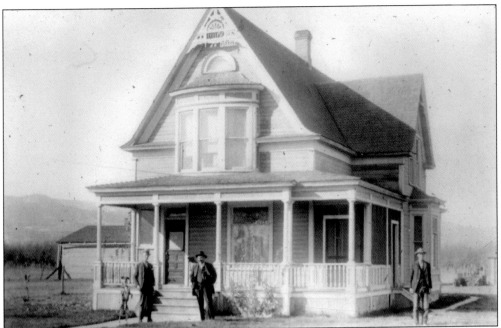

HUGHES RESIDENCE. This farmhouse, located south of the railway tracks on South Mesa Street and pictured in 1913, was constructed in 1905 by Bernard F. Hughes and his brother John. Bernard Hughes served as president of the Fruita Fruit and Produce Association and operated an apple orchard on the property. Although designated a Fruita Historic Landmark in 1997, the property was razed in 2002 to make room for a shopping plaza.

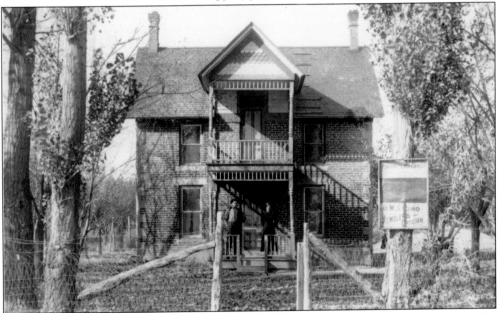

PENNSYLVANIA RANCH. This brick farmhouse was the residence of the George W. Stong family, who lived here when this photograph was taken in 1913. The building also served as Stong's place of business as Fruita's optician and jeweler. The house still stands on 18 Road, which was rural farmland when it was built.

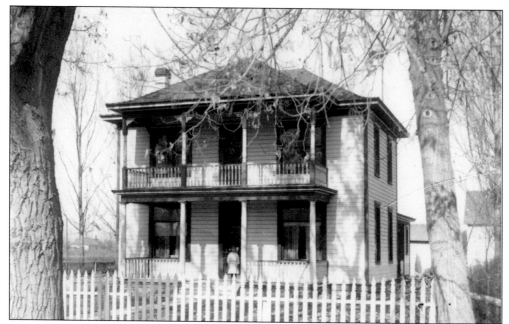

Farmhouse on East Pabor Avenue. This frame house was built in the first years of the 20th century and was surrounded by orchards in the first few decades of its existence. When the house was built, Pabor Avenue marked the northern boundary of Fruita. As the orchards diminished, the farmland was filled in with other homes, but this house still stands.

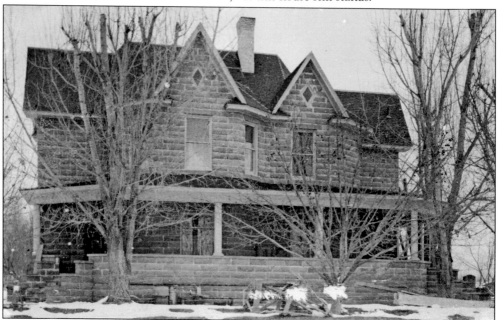

Stonehaven Manor. Harry and Lilly Phillips's concrete block home, located at 798 North Mesa Avenue, was built in 1908 and was one of Fruita's largest early residences. The home has been both a private residence and a bed-and-breakfast. It is listed on the national, state, and local historic registers. This image is from a real photograph postcard mailed from Fruita in 1911. (Authors' collection.)

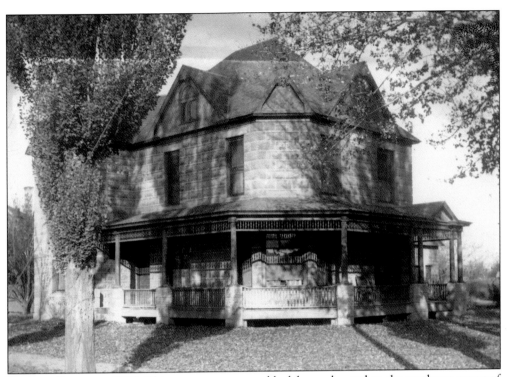

MAHANY RESIDENCE 1913. This two-story concrete block home, located on the northeast corner of East Pabor Avenue and North Mesa Street, is not typical of Mesa County homes built at the time, as most homes were constructed of either frame or brick. Albert Mahany, who built the home in 1906, owned a concrete block factory in Fruita that made the blocks for this, and many other Fruita buildings, in molds.

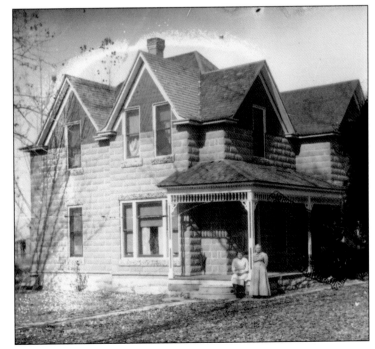

JAMES TURNER HOME. One of several concrete block structures built in Fruita in the first decade of the 20th century, this large, two-story home is located on the northwest corner of East Pabor Avenue and North Cherry Street. The house was built by James Turner, and this photograph was taken in 1913. Like the other concrete block houses pictured on these pages, this house still stands proudly today.

105

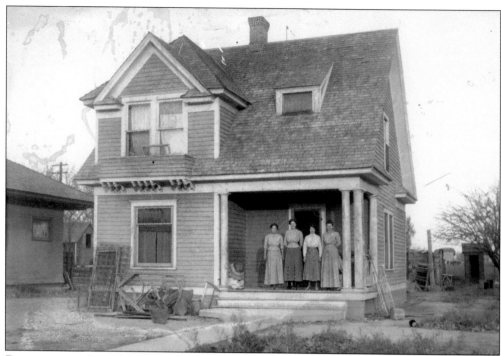

RESIDENCES ON SOUTH APPLE STREET. Apple Street, named by town founder William Pabor, is a residential street located near the downtown business district. In the image above, four women pose on the front porch of this two-story home in 1913. The photograph shows the clothing fashions of the time. The house was designed in the National Folk style, and an addition to the front of the house, where the porch was, has been added since. The home below, also photographed in 1913, was owned and lived in at a later date by Michael Fromm, who made shoes and operated a saddle and harness shop in Fruita for many years, and his second wife, Cora.

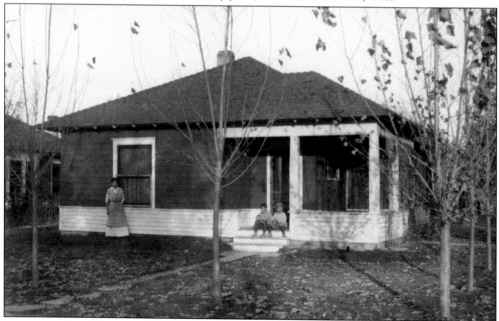

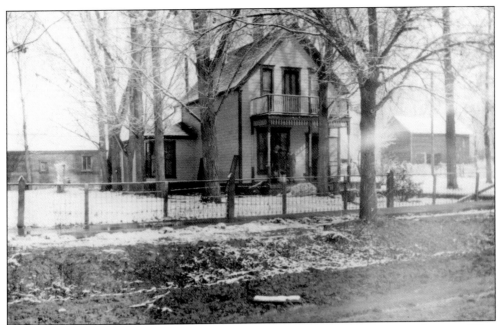

ROTH FAMILY RESIDENCE. Joseph and Iris Roth lived in this wood-frame, two-story home on West Pabor Avenue. The Interurban train tracks ran on the unpaved street in front of their house. The photograph was taken by their daughter, Pearl Roth Roach. Like the Roth family homestead, this house no longer exists.

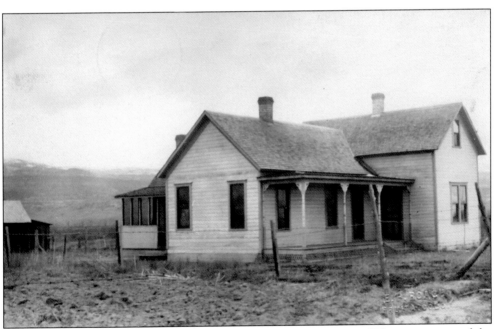

HOUSE FOR SALE. This postcard mailed by W. E. Boyd in 1912 states, "This is a picture of the house situate [sic] on the eight acre tract in Fruita, this will give you an idea, but does not show the trees or orchard, the raise that you see in the back-ground [sic] is four or five miles away, across the valley of the Grand River." (Authors' collection.)

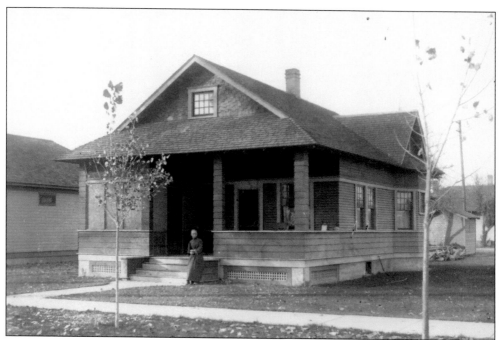

EAST ASPEN AVENUE RESIDENCE. East of the downtown business district, along East Aspen Avenue, sits one of the primary original residential districts of Fruita. A large number of houses are situated along the street, many of them on larger lots than on the side streets that radiate off Aspen. This home, photographed in 1913 by Minnie Hiatt, is built in the prairie style.

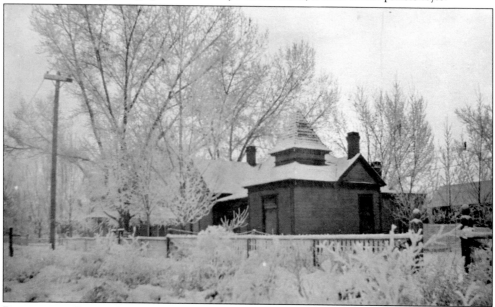

POSTMASTER BRUNER'S HOUSE AND BARN. This image was taken by Pearl Roach, possibly in January 1914 when she took several similar photographs, and highlights the heavy hoarfrost on Frederick S. Bruner's property, which is located on the southwest corner of West Pabor Avenue and North Cherry Street. The house, which normally would have been visible in winter, is completely obscured by hoarfrost-covered trees. The house and barn still exist.

Six

HAVING FUN

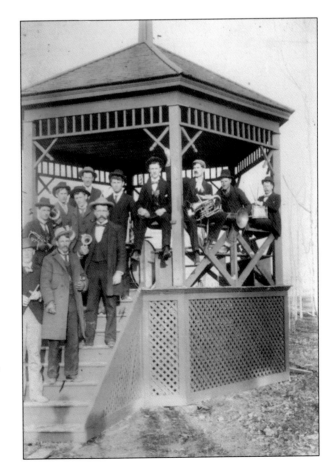

FRUITA'S FIRST BAND. Wanting to offer musical entertainment to the citizens of the new town, Hilarian Charles "Charley" Wagner formed a coronet band in 1887 or 1888. The band played at weddings, picnics, outdoor concerts, and other local events. The members at the time of this turn-of-the-century photograph included James T. Nichols, Charles Mahany, Carl Osborn, Charles Wagner, Jim Brown, John Innes, Charles Weckel, and Edwin Weckel.

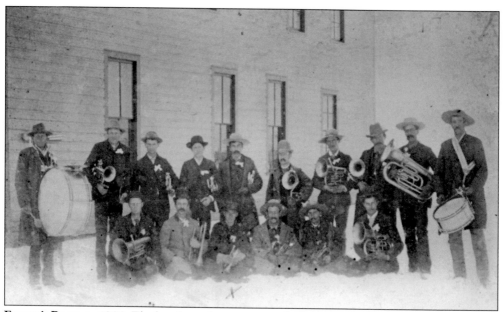

FRUITA'S BAND IN 1888. The band members posing with their instruments are, from left to right, (first row) Addison Kirk, Ernest Frank, James T. Nichols, George Williams, Wesley Foster, and Vince Wagner; (second row) Lester Johnson, Leonard Johnson, Gus Chevalier, Charles Mahaney, Hilarian C. Wagner, Edward T. Fisher, Thomas Brown, Benjamin Kiefer, Fred Vosburg, and Frank Lambertson.

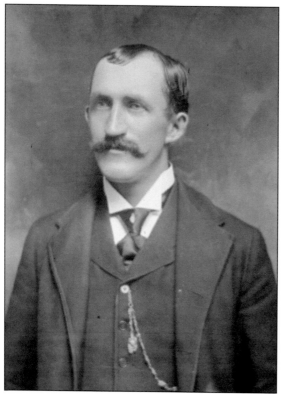

HILARIAN CHARLES WAGNER. Hilarian C. "Charley" Wagner was one of Fruita's early pioneers. He served as editor of Fruita's first newspaper, the *Fruita Star*, in 1889 and later as the editor of the *Mesa County Mail*. Wagner, who was a professor of music at Valparaiso University in Indiana before moving west to Fruita, was proficient in several languages and was instrumental in developing a cultural life in Fruita.

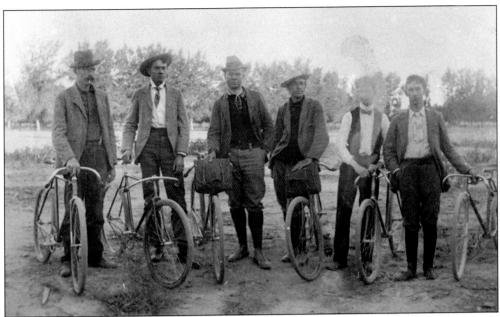

THE SOCIAL WHEEL CLUB. One of the earliest sporting clubs in Fruita, this competitive bicycle club was formed in July 1897. The original members included McCune G. "Mack" Talley, Edgar Beard, and George Bruner. They took part in a number of local races, and they rode their bikes from Fruita to Glenwood Springs, over 100 miles away, for an annual race. Although they were serious bicycle riders, they also participated in social events, as the name suggests, and took time out for good-natured fun, as can be seen in the photograph below. They initiated a pastime in Fruita that persists to this day: Over a century later, bicycling remains the top recreational event in Fruita.

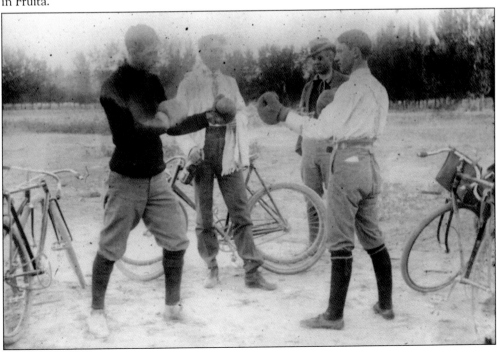

Social Wheel Bicycle Club Medal. This medal was won by John Beard in 1901 for finishing first in the 23-mile race from Basalt to Glenwood Springs in the record-breaking time of 1 hour, 16 minutes, and 23 seconds. Contestants rode single-speed, back-braking bikes over an unpaved mountain road. Fans watched the race from the train that rode alongside the road and cheered-on the riders.

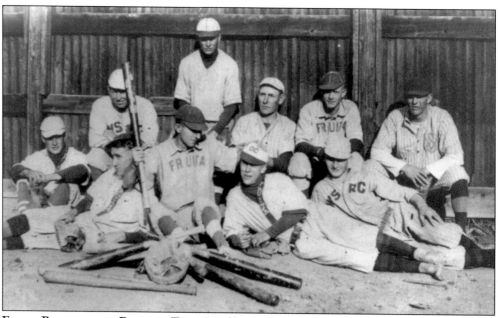

Fruita Recreational Baseball Team. In addition to students playing organized sports at school, adults formed their own athletic teams. Team members in 1919 are, from left to right, (front row) Michael Fromm, Pat Hill, Roy Adams, and Chert Phillips; (back row) Jess Dennis, Lester Sumnick, Ernest Redman, Ernie Swindell, Wade Gore, and Lyle Deal.

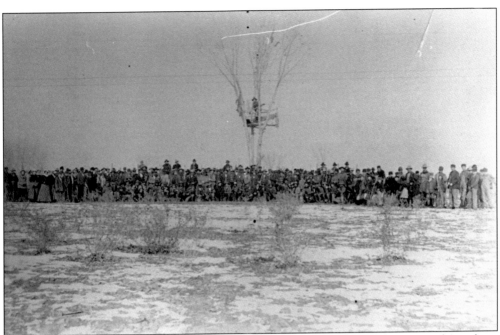

COMMUNITY COYOTE HUNT. There were many coyotes in the area, and the townspeople's garbage and small livestock attracted them into town. An organized hunt took place each year between 1897 and 1902 to keep down the coyote population and keep them out of the town. The annual event attracted many local citizens, as can be seen in the photograph above.

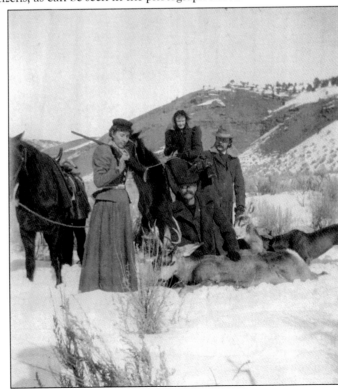

HUNTING PARTY IN 1898. Flora Green, wearing a cap and holding a rifle, and other Fruita residents took part in a successful hunting expedition in 1898. Hunting and fishing in the surrounding mountainous areas have always been popular pastimes for Fruita residents as well as providing food for the table. Green was a half-sister to Pearl Roach.

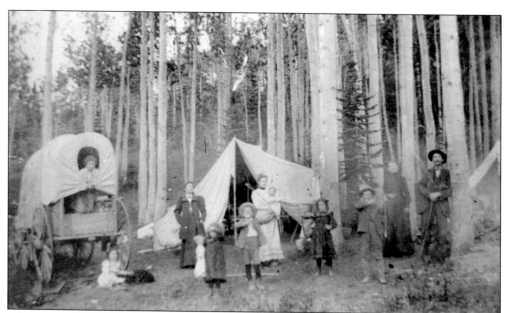

PIÑON MESA CAMPING TRIP. Albert Mahany's family posed for this photograph about 1900. A Chamber of Commerce booklet in 1906 stated, "The proximity of the Rocky Mountain range to Fruita makes it easy to escape the heat of the summer for a season, all that is required being a team and wagon, tent and camping outfit; a day's drive into the mountains takes one to where frosts occur every month in the year."

GLEN ALPINE SKI CLUB. The first ski club in the Grand Valley was formed in Fruita. Pictured during Christmas 1923, from left to right, are ski club members Wallace Beard, Irving Beard, and Milton Osborn. Also in the ski club at the time were Rodney Anderson, Merle Nichols, Clive Minor, Virgil Minor, Charles Nichols, Leo Markrud, and Kenneth McCoy.

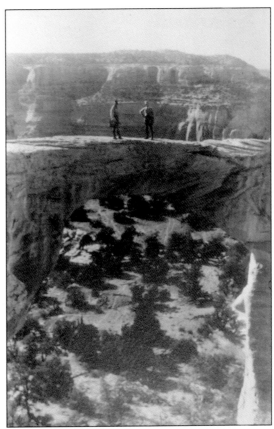

RATTLESNAKE CANYON. Around 1925, John Beard, his son Irving, and Lucius Moore traveled west of Fruita to climb on the arches at Rattlesnake Canyon. In the photograph above, Irving (left) and John Beard pose atop the arch usually called Akiti Arch. John Beard stands atop what is sometimes called Trail Arch below. This is a long and arduous trip even today, as the roads in the area are largely hand-cut and difficult and a fair bit of backcountry hiking is required—although the beautiful scenery makes the effort worthwhile. This area of spectacular red-rock formations is located west of the Colorado National Monument and is currently operated by the Bureau of Land Management.

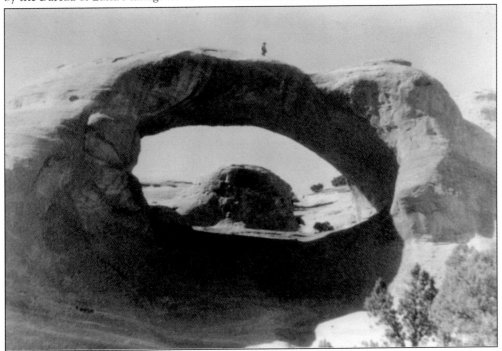

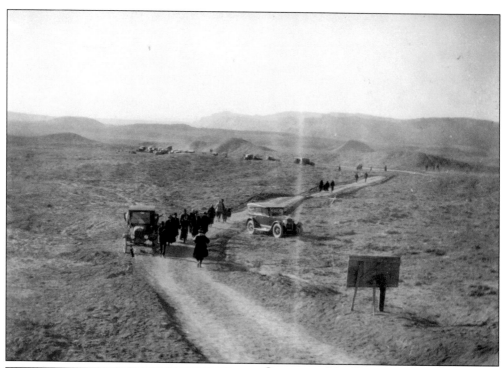

OUTING TO MT. GARFIELD. A group of Fruita citizens took a winter trip to Mt. Garfield, near Palisade, sometime in the mid-1920s. This photograph shows the travelers and their vehicles as they made their way through the parched desert landscape. The entire area looked much like this before the introduction of irrigation. The car in the foreground on the right is a 1925 or 1926 Buick touring car.

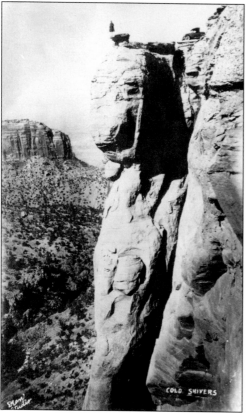

COLORADO NATIONAL MONUMENT. The scenic red-rock area south of Fruita was declared a national monument in 1911. It was a favorite playground of Fruita residents, especially after 1907, when the Fruita Bridge made it convenient to cross the river. This photograph by Grand Junction "fotografer" Frank Dean shows a woman perched perilously atop Cold Shivers Point, one of the rock formations in the monument. (Courtesy of Bobbi June Fisher.)

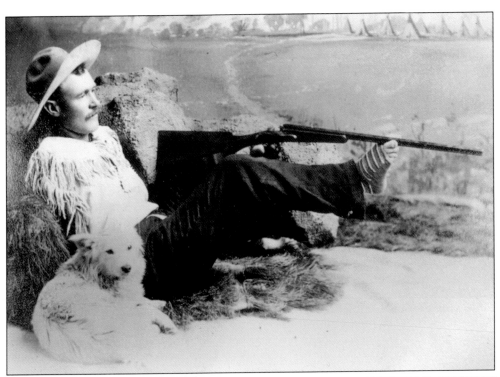

JOHN OWENS. One of 12 children, John Timothy Owens was born in Missouri in 1865 to Nicholas Owens and Mary Ann O'Keefe. By 1880, the Owens family had moved to Colorado and had settled in Fruita sometime before 1900. Despite having been born with no arms and having to use his feet for everything hands are normally used for, John could write and played the harmonica, fiddle, banjo, and guitar. He drove a team of horses, harnessed them, and could saddle a horse. He performed whip tricks and could shoot a rifle. He wore specially made kick-off shoes and toeless socks so he could quickly access his vital feet. He married stage musician Matilda Fry, with whom he had three children, and together they toured with Wild West shows. He died in Missouri in 1918.

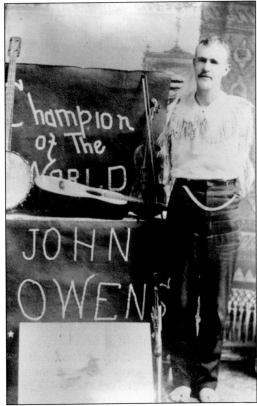

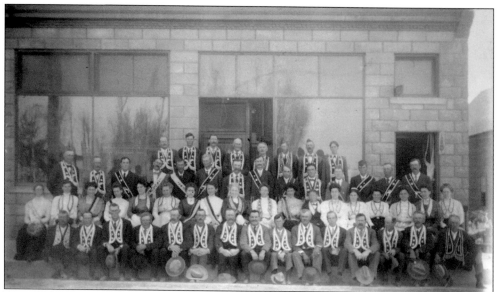

INDEPENDENT ORDER OF ODD FELLOWS. One of several social and fraternal orders in Fruita, the IOOF Fruita Branch was established in 1904. The Silver Bell Rebekah Lodge was founded for women in 1906. This combined group photograph was taken outside of the First Bank of Fruita building, where the lodges met upstairs, in the fall of that year. It would be many years before they purchased the IOOF hall.

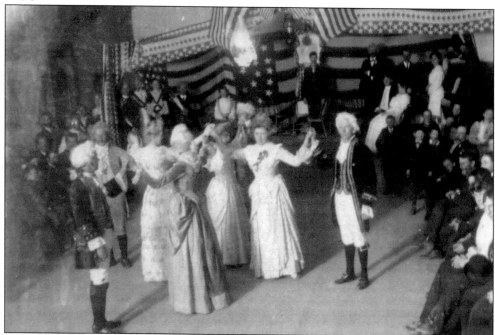

WASHINGTON'S BIRTHDAY CELEBRATION. The Order of Washington was one of many social clubs started early in Fruita, and the organization appealed both for social and patriotic reasons. The national order was established in 1895, and membership was limited to descendants of Revolutionary War patriots. The members of the Order of Washington are pictured at the Washington's Birthday Pageant in 1906. Edwin Weckel played George Washington.

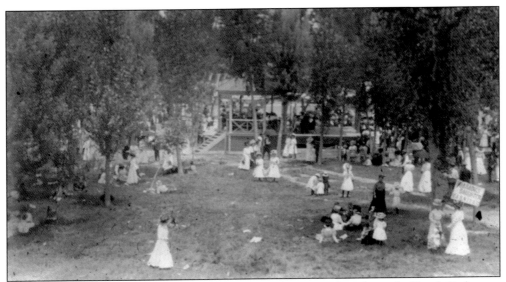

PHAROAH'S DAUGHTER CARNIVAL. Fruita's citizens love attending festivals. Bronk Park, now known as Circle Park, in the center of Park Square is the perfect location for fairs and carnivals and has hosted many throughout the years, including this one in 1910. The Pharoah's Daughter Carnival was probably hosted by the Silver Bell Rebekah Lodge.

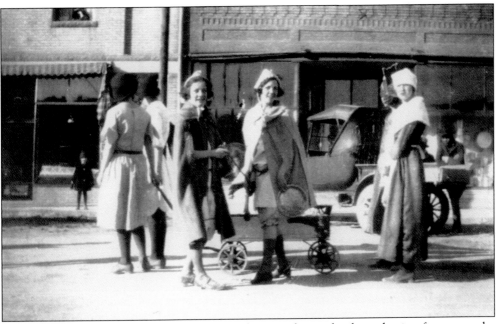

NURSES ON PARADE. East Aspen Avenue, in the shopping district, has been the site of many parades throughout the decades. The women taking part in this World War I–era parade are dressed as nurses and were most likely raising awareness for the war effort or the Red Cross.

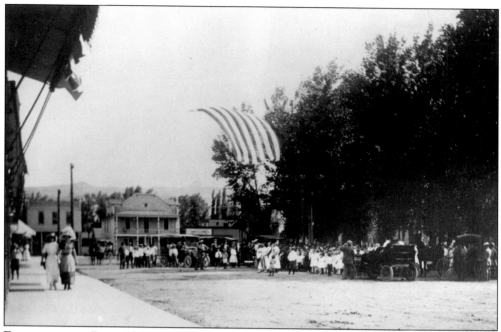

FESTIVAL IN THE PARK. This summertime celebration in Park Square was photographed by Pearl Roach, probably in 1912. The electrical lines are already up, but the broad sign seen attached to the balcony of the Park Hotel in photographs from 1913 on is not. A couple dozen people are looking skywards. Aviation pioneer Charles F. Walsh flew at the Grand Junction Fairgrounds in 1912; perhaps he gave Fruita a flyover.

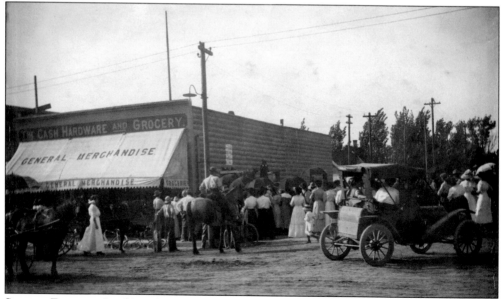

SUMMER FESTIVAL. Pearl Roach captured these 1912 carnival goers in front of the Cash Hardware and Grocery at the northwest corner of East Aspen Avenue and North Peach Street. Among many other products, the store sold Buster Brown shoes, made by the Brown Shoe Company, which had long hired midgets accompanied by American Pit Bull Terriers to perform at retailers as Buster Brown and his dog, Tige, as seen here.

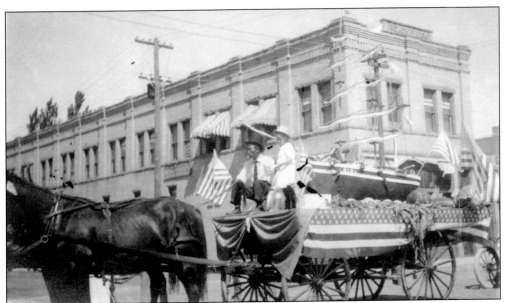

COLUMBUS DAY FLOAT. A horse-drawn carriage featuring Christopher Columbus's ship the Nina makes it way westward down East Aspen Avenue as part of a celebration of America's heritage and the annual harvest. It is shown here in front of the Beach Block building. The signs for Andrew V. Sharpe's Real Estate Company and the automotive garage to the right of the Beach Block date the photograph to about 1917.

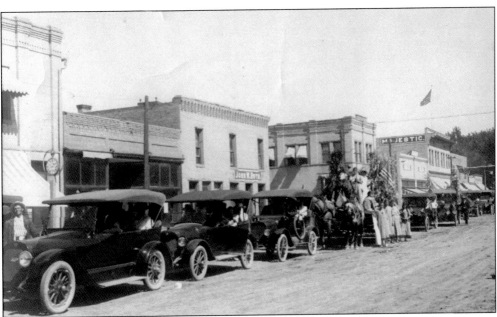

COLUMBUS DAY PARADE. In what might be part of the same parade, a line of automobiles and a horse-drawn carriage head west down an unpaved East Aspen Avenue toward Park Square. John Roth's office can be seen on the left, and farther up the street can be seen the Beach Block and the Majestic Theater. The business signage along the street indicates the photograph was taken around 1917.

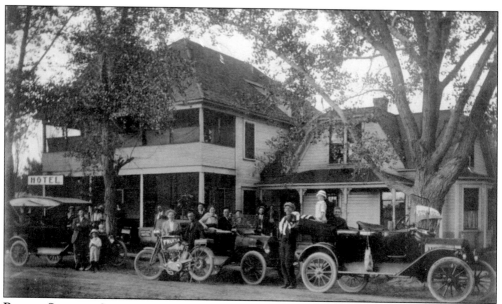

PARADE STAGING. Sporting Fruita pennants, celebrants wait with their vehicles in front of the White House Hotel on South Mulberry Street for a homecoming or similar parade. William Roach leans against the family car, far left. Bernard Roach climbs in the back; his apparent age dates the photograph to about 1916; Bernard died in the Spanish Flu pandemic at the age of six. An early Harley Davidson sits at center.

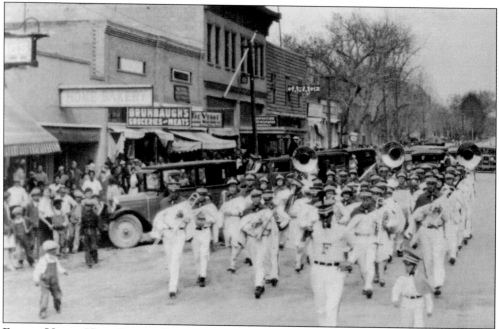

FRUITA UNION HIGH SCHOOL BAND. Drum major Leo Markrud leads the Fruita Union High School Marching Band down East Aspen Avenue in about 1930. Visible shops include the Home Bakery, operated by Harry Collins; the Brumbaugh Grocery Market; Pearl Roach's millinery, The Vogue; and the Majestic Theater, then owned and operated by Fred and Carrie Fraser, later owned by Robert and Melba Walker.

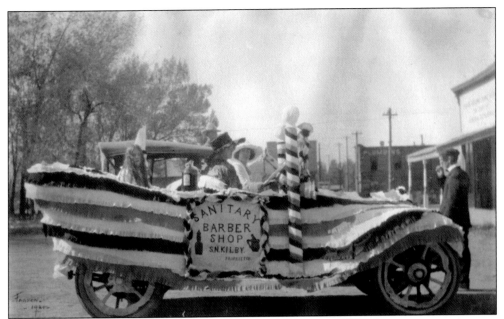

SMITH KILBY FLOAT. The annual Cowpunchers' Reunion featured a parade down Aspen Avenue. This float from the 1921 parade advertised Smith Kilby's Barber Shop and featured striped barber poles. The float took second prize in the parade. The car was driven by Ellen Kilby. The passengers were Stella Kilby in the front seat and Maxine Goss in the back seat.

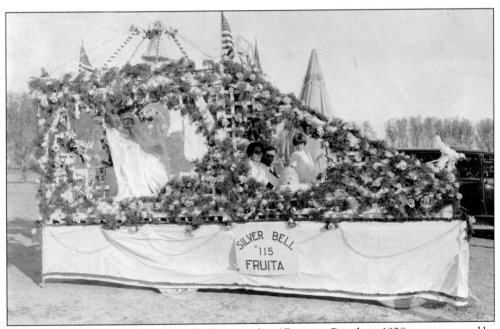

SILVER BELL FLOAT. This float from the Cowpunchers' Reunion Parade in 1928 was sponsored by the Rebekah Lodge No. 115. From left to right, Sara Cuddy, Michael Fromm, and Leola Cuddy are seated in the front. The Rebekah Lodge was part of the Independent Order of Odd Fellows. The Fruita chapter, known as Silver Bell, was established in 1906.

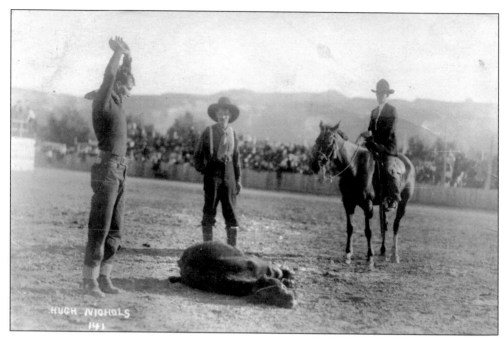

COWPUNCHERS' ANNUAL RODEO. The Cowpunchers' Reunion was started in 1914 by Dr. Robert B. Porter and a group of others who contributed $100 each to initiate the program. The reunions were held every fall and included rodeos and a parade down Aspen Avenue. The Cowpunchers' Reunion evolved over the years into the Fruita Fall Festival, which is a three-day festival held every September with more than 150 vendors selling arts, crafts, and food to a crowd estimated at more than 50,000. These photographs taken in 1921 show the cowpunchers participating in two rodeo events, calf roping and wild horse racing, while being watched by hundreds of local residents. The horse race was won by Lorraine Fisher, a local high school student.

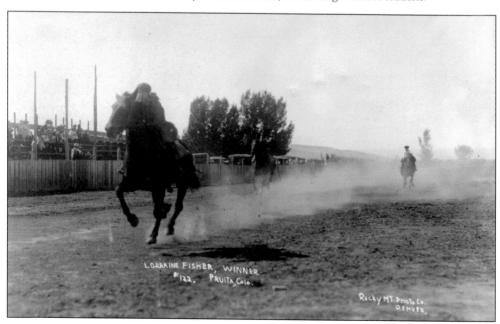

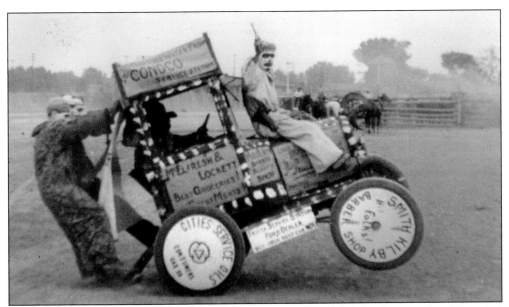

RODEO CLOWN BUCKING FORD FLOAT. This float was created for the Cowpunchers' Reunion parade and rodeo. The axle was off center to creating the bucking effect. The Ford was plastered with sponsorship advertisements for a variety of local businesses. The clowns were Ray Grant, Ed Larsen, and Benny Coats. The rodeo grounds were built south of the railroad tracks, and the town's businesses closed for the rodeo and the parade.

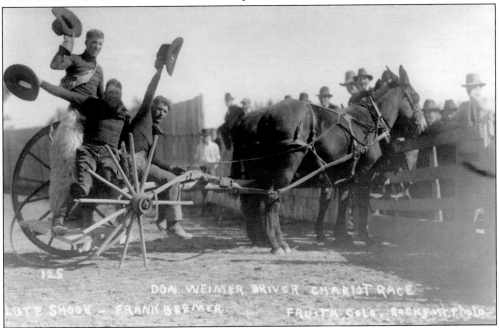

COWPUNCHERS' CHARIOT TEAM. One of the events in the Cowpunchers' Rodeo was the chariot race. A "chariot" was little more than two wagon wheels, an axle, and a platform hanging off them pulled by horses. This was a fun and exciting event watched by a huge crowd cheering for their favorite teams. From left to right, Lute Shook, Frank Bremer, and Don Weimer posed for the camera after their wheel-shredding, victorious race in 1921.

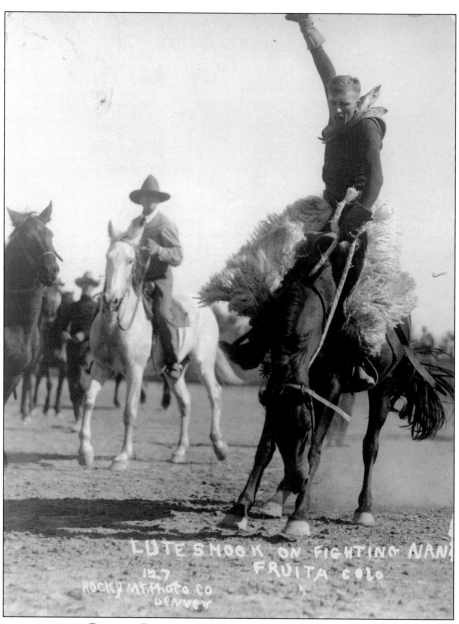

COWPUNCHER ON A BUCKING BRONCO. Cowboy Lute Shook hangs on tightly as he rides the jumping and bucking mare Fighting Nan during the 1921 Cowpunchers' Reunion Rodeo. Hundreds of Fruitans, as well as numerous visitors from around the region, enjoyed the spectacle put on by dozens of rodeo participants drawn in from all walks of life from all parts of Colorado, Utah, and beyond. Contestants included cowhands and clerks, dough bellies and doctors, wranglers and retailers. Men or women, black or white, could participate—and did. Then as now, Fruita is a diverse community of farmers and ranchers, business owners and employees, students and retirees. Fruitans work hard, play hard, enjoy the outdoors, and appreciate everything that Western Colorado has to offer. Like every American city or town, Fruita has seen its share of victories and defeats, booms and busts, and ups and downs, but like Lute Shook busting a bronco, we Fruitans just keep hanging on.

BIBLIOGRAPHY

Barcus, Earlynne and Irma Harrison. *Echoes of a Dream: The Social Heritage of the Lower Grand Valley of Western Colorado.* Fruita, CO: Fruita Triangle, 1983.

Bergner, Merton Nolan. "The Development of Fruita and the Lower Valley of the Colorado River from 1884 to 1937," master's thesis, University of Colorado, 1937.

Bowen, A.W. *Progressive Men of Western Colorado.* Chicago: A.W. Bowen and Company, 1905.

Burnham, Al. *Record of Fruita Fire Department From 1921 to 1933.* Unpublished handwritten journal. Fruita, CO.

Fruita Bureau of Information. *Fruita, Colorado.* Fruita, CO: 1910.

Fruita Chamber of Commerce. *Fruita, Colorado: Climate and Crops, Facts and Figures.* St. Joseph, MO: Press of the Fruit-Grower, 1906

Fruita High School: 100 Years. Fruita, CO: Fruita Monument Class Reunion Committee, 1993.

La Salle, Albert and Terry La Salle. *An Early History of Public Education in the Grand Valley: Volume One, Reorganization.* Grand Junction, CO: Mesa County Valley School District 51, 2001.

McCreanor, Emma. *Mesa County, Colorado: A 100 Year History.* Grand Junction, CO: Museum of Western Colorado Press, 2002.

McGuire, William and Charles Teed. *The Fruit Belt Route: The Railways of Grand Junction, Colorado 1890–1935.* Grand Junction, CO: National Railway Historical Society, Rio Grande Chapter, 1981.

Pabor, William E. *Colorado as an Agricultural State: Its Farms, Fields, and Garden Lands.* New York: Orange Judd Company, 1883.

Pabor, William E. *Wedding Bells—A Colorado Idyll.* Denver, CO: The Reed Publishing Co., 1900.

Thomas, Gene and Pat Thomas, eds. Special 75th anniversary edition, *Fruita Times* 65, No. 40. October 15, 1959.

DISCOVER THOUSANDS OF LOCAL HISTORY BOOKS
FEATURING MILLIONS OF VINTAGE IMAGES

Arcadia Publishing, the leading local history publisher in the United States, is committed to making history accessible and meaningful through publishing books that celebrate and preserve the heritage of America's people and places.

Find more books like this at
www.arcadiapublishing.com

Search for your hometown history, your old stomping grounds, and even your favorite sports team.